FASHIONING fiction
in photography since 1990

THE MUSEUM OF MODERN ART
NEW YORK

FASHIONING
fiction
in photography
since 1990

SUSAN KISMARIC and **EVA RESPINI**

Published on the occasion of the exhibition *Fashioning Fiction in Photography
since 1990,* organized by Susan Kismaric, Curator, and Eva Respini, Assistant
Curator, Department of Photography, The Museum of Modern Art, New York,
and shown at MoMA QNS April 16–June 28, 2004.

The publication is made possible by a generous grant from
Carol and David Appel.

The educational programs accompanying the exhibition
are made possible by BNP Paribas.

Additional funding is provided by the Council of Fashion Designers of
America and The Junior Associates of The Museum of Modern Art.

Produced by the Department of Publications
The Museum of Modern Art, New York
Edited by Harriet Schoenholz Bee
Designed by Naomi Mizusaki, Supermarket, New York
Production by Marc Sapir
Typeset in Didot and Grotesque
Printed and bound in China by Oceanic Graphic Printing, Inc.,
on 150 gsm New G Matt artpaper

Library of Congress Control Number: 2003114870
ISBN: 0-87070-040-5

Published by The Museum of Modern Art
11 West 53 Street, New York, New York 10019
www.moma.org

Distributed in the United States and Canada by
D.A.P. / Distributed Art Publishers, Inc., New York

Distributed outside the United States and Canada
by Thames and Hudson, Ltd., London

Cover: Cedric Buchet. Prada advertising campaign.
Spring/Summer 2001

Printed in China

10

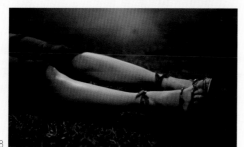
68

contents

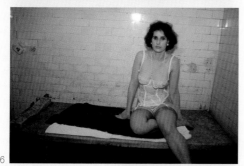
68

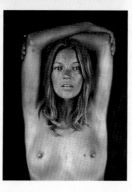
128

foreword

Fashion photography has appeared regularly at The Museum of Modern Art, for it has made an indispensable contribution to the vitality of modern photographic traditions. Nevertheless, *Fashioning Fiction in Photography since 1990* is the first MoMA exhibition devoted exclusively to the subject.

The exhibition is not a survey, however. It is a sharply focused critical consideration of a particular creative episode that took shape in the 1990s. As advertising campaigns and magazine editorials adapted to evolving lifestyles and markets, fashion photographers confronted a new challenge. This challenge attracted the talents of both commercial professionals and independent artists, fostering a lively exchange and yielding the fresh narrative strategies that are set forth in the exhibition and examined in the book.

I applaud and thank Susan Kismaric, Curator, and Eva Respini, Assistant Curator, Department of Photography, who together conceived and executed *Fashioning Fiction*. Their collaboration exemplifies the Museum's commitment not merely to celebrate recent artistic developments but also to examine and clarify them. I am grateful as well to Dennis Freedman, Creative Director of *W* magazine, for contributing his illuminating interview with the two curators.

I am pleased to express the Museum's gratitude to Carol and David Appel, whose generous support made this elegant publication possible. The educational programs associated with the exhibition have been made possible by BNP Paribas, and additional funding has been provided by The Junior Associates of The Museum of Modern Art.

Glenn D. Lowry
Director
The Museum of Modern Art

acknowledgments

First and foremost, we are deeply grateful to the photographers whose work is included herein; without their extraordinary work and their cooperation, the exhibition and this volume would not have been possible. We also owe a debt of gratitude to many other people for their advice and assistance. Chief among them is Dennis Freedman, Creative Director of *W* magazine and Vice Chairman of Fairchild Publications, who spent many hours with us in order to provide an insightful and engaging interview that describes the inner-workings of the fashion industry. Mr. Freedman also helped direct our research and generously provided hospitality within the world of fashion for which we expressly thank him. His assistant Ksisay Torres was of immeasurable help throughout, especially in locating him. Alexandra White, Senior Fashion Editor at *W* spoke at length with us about her work, as did Joe Zee, Fashion Director at *W*.

For the works in the exhibition and publication we relied on the generosity and expertise of many individuals. The private and public lenders of Cindy Sherman's photographs are appreciated for graciously parting with these major works in their collections; they are John Cheim, the Center for Curatorial Studies at Bard College, Rita Krauss, Sondra and David S. Mack, the Ann and Mel Schaffer Family, and Gary W. Sibley. The photographers' agents and representatives have been of great assistance in providing material for review and in answering endless questions. Among them are the following: Janet Borden, Director, and Matthew Whitworth, Assistant Director, Janet Borden, Inc., for Tina Barney; John Moore, Agent, and Walter Schupfer, Director, Walter Schupfer Management Corporation, for Cedric Buchet; Leslie Simitch, for Philip-Lorca diCorcia; John Marchant and Markus Jans, Studio Assistants, and Jeffrey Peabody, Director, Matthew Marks Gallery, for Nan Goldin; Tom Heman, Director, and Allison Card, Registrar, and Helene Weiner and Janelle Reiring at Metro Pictures for providing assistance with the work of Cindy Sherman; Steve Sutton, Studio Manager, and Natalie Doran, former Producer at Smile Management, for Mario Sorrenti; Julia Leach, Vice President, Creative Services at Kate Spade, and Ziggi Golding-Baker, Z Photographic International Marketing, New York, for Larry Sultan; Katy Baggott and Adele Smith, in London, and Rachel Lehmann and David Maupin, Directors, and Juliet Gray, Assistant Director, at Lehmann Maupin Gallery, New York, for assistance with the work of Juergen Teller. Neither the exhibition nor the book could have been achieved without the staff of Art + Commerce in New York, who provided research materials at the outset of the project and further assistance in reference to three of the photographers: Glen Luchford, Steven Meisel, and Ellen von Unwerth; they

are James Moffat, Anne Kennedy, Carol LeFlufy, Rebecca Lewis, Andrée Chalaron, Lindsey Thompson, Ann Meere, Laura Palmer, and Michael van Horne.

In the Department of Publications at the Museum, Michael Maegraith, Publisher, is acknowledged for his approval and support of the project, especially since it was proposed at a late date. The editing of the book by Harriet Schoenholz Bee, Editorial Director, has been exemplary. Marc Sapir, Production Director, has done a superb job of overseeing its production. Naomi Mizusaki, of Supermarket, has created a highly imaginative interpretation of the work within her design for the book, and we are especially grateful to her.

Pascal Dangin, of Box Ltd., provided superb reproductions for the catalogue and prints for the exhibition of the work of a number of the photographers in the exhibition and shared with us his extensive knowledge of the world of fashion photography. We would also like to thank Marion Soulie, Exhibition Director at Box Ltd.

In the Museum's Department of Photography, we would like to thank Peter Galassi, Chief Curator, whose reading of the text improved it enormously. Rachel Crognale, Assistant to the Chief Curator, cheerfully handled administrative duties. Through the Museum's Department of Education, two curatorial interns, Joanna Kleinberg and Musee Wu attended to countless details with great patience and skill. Jennifer Russell, Deputy Director for Exhibitions and Collections Support, and Carlos Yepes, Associate Coordinator of Exhibitions, provided good counsel in terms of the logistics of organizing the show. Jerome Neuner, Director of Exhibition Production, and David Hollely, Exhibition Designer and Production Manager, designed the exhibition space. Susan Palamara, Associate Registrar, oversaw the transport and registration of the exhibition with her usual professionalism. Peter Perez, Framing Conservator at the Museum, oversaw the framing of the works for the exhibition after lengthy discussions with the curators. Stephen Clark, the Museum's Associate Counsel, provided sound advice regarding the reproduction of work. Text figures were reproduced from digital scans executed by Jonathan Muzikar, Digital Imaging and Archive Specialist at the Museum's imaging studio.

In addition, the following individuals must be thanked for contributions that facilitated and encouraged our effort: George Russell, without whose exceptional advice the essay for the catalogue could not have been achieved; Cathy Horyn, Fashion Critic for *The New York Times,* spoke with us at length about her role as a fashion critic; Philip Gefter, Senior Picture Editor, *The New York Times*; Ingrid Sischy, Editor-in-Chief of *Interview* magazine provided research materials and ideas about the fashion industry that were of tremendous help; Yolanda Cuomo of Yolanda Cuomo Design told us the history of *View/Vue* magazine; Katy Barker of Katy Barker Associates generously shared her knowledge of the contemporary fashion photography industry; Andrew Roth of Roth Horowitz provided an introduction to the work of Mario Sorrenti.

A great variety of important details necessary to the project were provided through the generosity of Norma Stevens, Studio Director, and Jennifer Landwehr, Assistant to the Director, Richard Avedon Studio; Etheleen Staley and Taki Wise generously shared the work of their photographers with us and provided materials for the catalogue. Robert Stevens, Picture Editor, *Time* magazine; Charlotte Cotton, Curator of Photographs, Victoria and Albert Museum, London; Catherine Chermayeff; Alissa Schoenfeld of Pace/MacGill Gallery; Matteo Marsilli of Benetton; Jennifer Snow of *The Village Voice*; Katie Hall of Gap, Inc.; Annette Wenzel of Wilson/Wenzel; Laura Howard of Taschen USA; and Margit Erb of Howard Greenberg Gallery all contributed valuable information. Cynthia Cathcart, Librarian at Condé Nast, and Stéphane Houy-Towner, Librarian, The Irene Lewisohn Costume Reference Library of The Metropolitan Museum of Art, opened their archives and were exceedingly generous with their knowledge and time.

Thanks are due Glenn D. Lowry, the director of the Museum for his support throughout the project. We also thank Michael Margitich, Deputy Director for External Affairs, and the Museum's Department of Development for their efforts to raise funds for the project, especially Monika Dillon, former Director, Exhibition Funding, and Associate Director, External Affairs, and Mary Hannah, Development Officer.

A special debt of gratitude is owed Carol Appel, a member of the Museum's Committee on Photography, and her husband David Appel, a member of the Photography Council, for providing funding for this catalogue. Their enthusiasm for and generosity to this project has been a source of encouragement throughout our work. We also thank BNP Paribas for support of educational programs associated with the exhibition, and The Junior Associates of The Museum of Modern Art for additional support.

Susan Kismaric, Curator
Eva Respini, Assistant Curator
Department of Photography

FASHIONING
fiction in
photography

by **SUSAN KISMARIC** and **EVA RESPINI**

Fashion photography has followed the move of the fashion industry from the salon to the street. Like fashion, photography relies and thrives on change, not only through advances in technology but, more importantly, through the countless shifting cultural, social, and economic forces that drive the effort to sell clothes. Both fashion photography and fashion have shifted from being primarily reflections of the aspirations of the haute bourgeoisie to a new status emblematic of a diverse, rapidly evolving, and increasingly younger, visually sophisticated commercial environment in which the pace of change has taken on a new industry-driven rhythm.

This book focuses on a key aspect of fashion photography since 1990, a decade during which the genre moved away from the paradigm of an idealized and classical beauty toward a new vernacular allied with lifestyle, pop and youth culture, and the demimonde. The principal factors that led to this shift are changes in fashion itself, its audience, and the way it is marketed. Of great importance, too, was the emergence within art photography of techniques derived from commercial practices that were adapted to the marketing of fashion. One of the most significant changes in fashion photography, in this fertile chaotic environment, has been that its subject—*clothing*—has become subordinate to the photographic description of *lifestyle* and has thus been transformed from a frozen object of beauty in a tableau to a tantalizing aspect of a narrative that is primarily about life as we now live it. As a consequence, much fashion photography has ceased to capture a timeless moment, and instead attempts to represent a moment in time through the device of narrative. Two of the dominant narrative modes in fashion photography of the last decade are the influence of the cinema and the snapshot. Both strategies create story lines and interrupted narratives, which imbue the images with dramatic complexity as well as contribute to the aura of personal intimacy and authenticity. All of the work in this book is examined through one of these lenses; and while they are not the only influences on fashion photography, they are two that are also central to contemporary art photography. By using these two interrelated narrative strategies, the fashion world has turned to current trends in art photography, and in some cases turned to the artists themselves.

All of the photographs in this book and its accompanying exhibition were made on commission and were published as editorials in fashion magazines or as mass-marketed advertisements. Half of the photographers featured here can be defined principally as artists and the other half as commercial professionals. However, the fluidity (and some would argue, futility) of these categories represents a particularly fruitful moment in the exchange between fine art and commercial photography. The dialogue between the two photographic fields has always been vital, and the character of this relationship has varied over time. To be sure, art has always influenced fashion, and there have been instances when earlier fashion photographs have been perceived as art, as seen in the work of Edward Steichen, Cecil Beaton, Baron Adolf de Meyer, Horst P. Horst, Irving Penn, and Richard Avedon, among others. The cross-fertilization has always benefited both art and applied photography, and continues to do so today.

The last ten years, however, have been particularly ripe for the exchange between art and fashion photography. The use of commercial photographic techniques by art photographers and the influence of art photography on fashion photography reflect a somewhat fraught exchange of sensibilities between the contemporary art world and consumer culture. This dislocation of the subject of fashion fosters an interchange of influences, perceptions, techniques, and communication between art and fashion photography. The saturation of imagery in contemporary life has become a preoccupation of art and, in particular, art photography. Contemporary commercial imagery is ubiquitous, and the visual strategies used by every kind of photographer have been nurtured by images from film, television, home videos, countless magazines and newspapers, the Internet, and the instant output of digital cameras. The feedback between art and fashion photography has become increasingly prevalent and has provided an environment for fashion photography to evolve rapidly and in close relationship with art photography. This vibrant exchange has helped alter the look and subject of fashion photography in the last decade.

How significant a change this has been can be seen by first examining a number of photographic works of the past. The memorable fashion photographs of the generation of photographers who began working in the late 1940s exemplify the rigorous standards of that era. Their primary function was to describe clothes as they appeared on the model conceived as mannequin, the human incarnation of the seamstress's dress form on which clothes are fitted. This trend reached an apogee of sorts with the photographs by Irving Penn made in the 1950s and 1960s: iconic images of women who are paradigms of elegance. As in a still life, the clothes and the women are artfully arranged with meticulous attention focused on the uniqueness, originality, or stunning detail of the garment. Like the many women in Penn's images, the woman in his

1951 photograph, *Large Sleeve (Sunny Harnett), New York* (fig. 1), shows her face as one element of a still life. Harnett appears to be appended to the finely sewn sleeve, but not exactly wearing it. The woman and blouse together become an abstract image, one that highlights the fine stitching and beautiful drape of the sleeve, and boasts of the garment's excellent craftsmanship. Harnett and the other Penn women are the archetypes of elegance to which the viewer is attracted and which then become inspiring. They are not so much real women as compositions of finely drawn line, shape, and form. As in all tableaux, the animate is subordinate to the inanimate.

Penn and a select few other photographers of his generation saw their task in the strictest sense as the interpretation and description of clothes as the embodiment of perfection and elegance. It is a task that Penn himself performed brilliantly and with considerable wit. Precisely because of its adherence to abstract considerations, fashion photography of this order was immediately recognized as art; Penn's austere style was seen as very close to the formalism of the photographs of Harry Callahan.

At the same time, Penn's photographs and those of other highly talented fashion photographers of that era reflect an intrinsic value system. Their work displays idealized members of an upper social class, whose chief characteristics are good breeding and refinement. Encoded in such hierarchical values is an implied system of power, morality, good behavior, stability and propriety, and even aesthetics and beauty, to which larger segments of earlier generations automatically aspired, or so it was thought. In these earlier pictures, the power of privilege is understood as absolute, as are the crisp and elegant standards of beauty that are integrated with it.

The idealized life of the woman reflected in these pictures is available only to a few. But the implication is that it is a life to which everyone should aspire. In Penn's day, the term *lifestyle* was not widely used. But the idea of lifestyle as an emblematic fact was already a powerful force. The notion that one could adopt a lifestyle simply through the acquisition of clothes, vacations, and cars is closely aligned with the fruitful but often fraught American notion of self-reinvention, best memorialized by Jay Gatsby, the protagonist of F. Scott Fitzgerald's novel *The Great Gatsby.*

Penn's tributes to platonic beauty were created after photography itself had evolved along with changes in the means to take pictures. The fashion photograph as a tableau is intimately related to the clumsy and elaborate equipment that all photographers used to produce their images. A watershed technical development was the advent of portability. With the invention of the hand-held camera (the Kodak Brownie) at the turn of the century, amateur photographers could do something professional photographers could not do easily, that is, photograph with relative spontaneity. The professional photographer surpassed his amateur peers after the invention of the versatile 35mm camera and roll film in the mid-1920s. But the fashion photographer, dependent on elaborate styling and settings, was committed to a kind of portraiture. Eventually, however, this too began to change, and when it did the fashion photographer was able to bring the model out of the studio and literally onto the street, thrusting him or her into the world, albeit in an extremely edited and light-hearted way.

The genesis of this process can be seen in the photographs of the Hungarian-born photojournalist Martin Munkacsi, who exemplified the modern way of seeing the world and fashion's new place in it (fig. 2). Munkacsi arrived in America in the mid-1930s on assignment for Ullstein Verlag, the largest publishing house in Berlin, which produced many of the leading magazines of the day, including *Berliner Illustrirte Zeitung [BIZ], Koralle, Uhu,* and *Die Dame,* a magazine designed for the "new" woman. These publications and others were inspired by and identified through photographs that could be made with the 35mm camera because such pictures were full of believable spontaneity and vitality. The imaginative and intuitive editor of *Harper's Bazaar,* Carmel Snow, had seen Munkacsi's work in *Die Dame,* and although Munkacsi had never made a fashion photograph, she hired him to do a shoot on women's bathing suits. Subsequently, Snow offered him a contract to work at *Harper's Bazaar* under the legendary art director and innovator in magazine design, Alexey Brodovitch.

Over the next ten years at *Harper's Bazaar,* a new style of fashion photography—emphasizing action, movement, and the dynamism of human form—sprang into existence. Munkacsi photographed his models at sporting events, on the beach, running, or jumping. His images, full of movement, extended the narrative potential of the photograph and were in direct contrast to the staid studio pictures of Steichen, Beaton, and others. As Munkacsi remarked: "By any definition, a photographer who seeks to portray moods and drama or anything but mementos of the ice-age must respect the visual and emotional facts of life."

Munkacsi had arrived in the United States as the world was changing in many fields—art, mathematics, physics, psychology, and literature—affected by fascism and war in Europe. Fashion photography and the world it claimed to represent were also undergoing a fundamental reconfiguration. In the wake of the 1940s and during the ensuing Cold War, the notion of an idealized social hierarchy

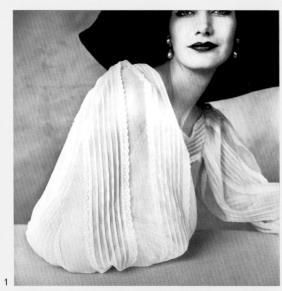

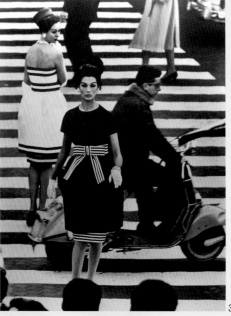

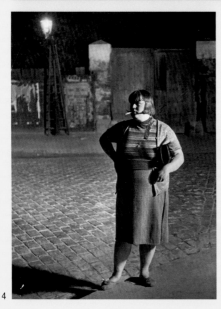

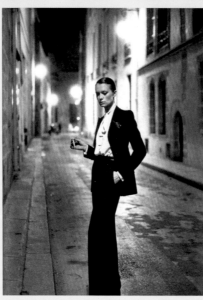

1. IRVING PENN. *Large Sleeve (Sunny Harnett), New York*. 1951. Gelatin silver print, 13 9/16 x 13 9/16" (34.5 x 34.5 cm). The Museum of Modern Art, New York. Gift of the photographer. 2. MARTIN MUNKACSI. *Spectators (Zuschauer)*. 1928. Gelatin silver print, 9 5/16 x 11 1/2" (23.7 x 29.2 cm). The Museum of Modern Art, New York. Joseph G. Mayer Fund. 3. WILLIAM KLEIN. *Piazza di Spagna (Vogue), Rome*. 1960. Gelatin silver print. 4. BRASSAÏ (Gyula Halász). *Streetwalker near the Place d'Italie, Paris*. 1932. Gelatin silver print, 11 3/8 x 8 3/8" (28.9 x 21.3 cm). The Museum of Modern Art, New York. David H. McAlpin Fund. 5. HELMUT NEWTON. *Rue Aubriot, Yves Saint Laurent*. Published in French *Vogue*, September 1975

could never be the same. The place it had held in the pictorial firmament was challenged by its democratic opposite, the notion of a popular and populist antiestablishment, which took its values from daily life, work, and entertainment: the embodiment of mass culture. During this time, prêt-à-porter eclipsed haute couture as a trendsetter in fashion. As the antiestablishment garnered equal status with the establishment, it became part of it, and then soon provided itself with a popular aesthetic—through photography.

Among the formative developments of the antiestablishment's new vision was the work of the irreverent Brooklyn-born expatriate William Klein, whose unflinching cynical look at his native city in his first book, titled *Life Is Good for You in New York: William Klein Trance Witness Revels*, published in Switzerland in 1956, is one of the key counterculture photographic documents of the 1950s. Initially, it did not find a wide audience and was barely distributed in the United States. Soon after, in 1959, the Swiss photographer Robert Frank's volume, *The Americans*, was published in the United States, and later became a model for subsequent photographers. Klein's New York book was a cult favorite of serious photographers and, in retrospect, can be seen as a kind of companion to Frank's book, but one in a more intimate and urban vein. Both books embody critiques of American culture.

Klein, who served with the United States Army in Europe during the war, had stayed on in Paris to study art with Fernand Léger, but then switched to photography. His technique was to use a 35mm camera on the run, often surreptitiously. His negatives were often exposed in shadows or low light, or at a slow speed so that a print from the negative included highly visible grain and blur. Klein's aggressive photographic style broke through the theatrical plane of staged artificiality, even as it brought the notion of theatricality into the street. The people he photographed often performed for the camera in public places. Or they were photographed so closely, and with such physical hostility, that our sense of the city he describes is one of deteriorating corporeality. The ultimate effect of his work is both cynical and moral. In his book on New York, Klein described a pious gun-toting population hopelessly corrupted by commercialism.

In the mid-1950s, Klein began working on assignment for *Vogue*, and has been involved with fashion photography ever since. He photographed for other fashion magazines as well, making photographs behind the scenes at couture houses and directing several films about fashion. In Klein's photographs, the model has become a woman whose visage is refreshing, tough, and not altogether pleasing. In terms of the photographic values expressed by Irving Penn,

the model and the clothes in Klein's images began a reversal in which the tough demeanor of the model held equal place with the clothes (fig. 3). The viewer was slowly, incrementally, being drawn down a path that was bringing the images of fashion closer to the "realities" of life.

Klein and the new antiestablishment photographers were changing the relationship between consumers of fashion and the images themselves; in the same way they were changing the subject of fashion photography. For readers of fashion magazines or viewers of fashion pictures, the relationship to the subject was being changed from that of observer to that of implicit participant. As fashion photographers changed the models from objects into active humans in realistic situations, they began to make the viewer an extension of these situations. They turned the viewer into part of the verb in the new grammar of fashion photography. Everything—model, clothing, background, lighting, situations, image, and viewer—participated in a narrative fantasy.

As fashion's narrative style drew photography closer to an antiestablishment view of reality, it also drew the realities of the demimonde into a new paradigm of normalcy. The German-born photographer Helmut Newton is notorious for the sexual content of his pictures. His nighttime tableaux of homosexuality and sadism are drawn from the photographs of Brassaï (Gyula Halász), the Transylvanian photographer who moved to Paris in the mid-1920s where he photographed the demimonde of the city with the bluntness of a police photographer (fig. 4). In one of the most original bodies of work in photographic literature, published in a censored version as *Paris de Nuit* (1933), Brassaï reveals a world where prostitutes, pimps, and homosexuals work and haunt the streets and clubs of nighttime pre–World War II Paris. In Newton's photographs (fig. 5), by contrast, the models are beautiful figures who wear tuxedos and light each other's cigarettes, have catfights, and stalk the midnight streets looking equally for sleek prey or victim-hood. In Newton's world, the demimonde has become beautiful, surreal, and psychological. When first seen in American *Vogue* in the early 1970s, Newton's pictures introduced the demimonde in all the right places: doctors' and dentists' offices, and on coffee tables.

Work of the 1950s through the 1980s by the French photographer Guy Bourdin is notable for its tongue-in-cheek sexuality and violence. Bourdin was the first explicit storyteller in fashion photography. Both the subjects and the styles of his pictures have become templates for the work of many others. Bourdin first exhibited his photographs in 1952 at Galerie 29 in Paris. The exhibition

catalogue included a dedication by photography's Surrealist master, Man Ray, who also made fashion photographs in the 1920s and 1930s. For over thirty years Bourdin's pictures appeared in the pages of French *Vogue,* and for twenty-two years he created the advertising campaigns for the shoe designer Charles Jourdan. Bourdin's fashion work was a direct confrontation with the perceived frivolity and vapid optimism of the postwar 1950s (fig. 6). His first published fashion photograph appeared in *Vogue* in 1955: a black-and-white image of an elegant model standing at a meat market in front of a rack of pigs' heads.

Many of Bourdin's photographs are made in hard-edged, evenly lit saturated colors and are graphically very simple. The countless mannequins in his pictures are derived from the work of the Surrealists of the 1920s and 1930s, and Surrealism remained an important influence on Bourdin throughout his career. By the 1960s, he had translated the Surrealist artist Hans Bellmer's dolls, or *poupées* (fig. 7), with their distorted bodies and intimations of death and torture, into a kind of pop-cartoon format. Many of his photographs from the period are like the panels of a traditional comic strip, where the action is compressed into the simple drawing of a series of highly dramatic moments. Bourdin's exaggerated violence, made palatable by his black humor and wit, is a theme subsequently explored by fashion photographers in the 1990s within their own cultural contexts and in their own styles. Glen Luchford's advertising campaigns for Prada (pages 68–75) owe a debt to the ground-breaking work of Bourdin, as do Philip-Lorca diCorcia's cinematic dramas (pages 42–53).

In 1976, Bourdin was commissioned by Bloomingdale's department store in New York to produce the photographs for its fall lingerie catalogue. Enigmatically titled "Sighs and Whispers," perhaps a takeoff on Ingmar Bergman's film *Cries and Whispers* (1972), the catalogue appeared as an insert to the Sunday *New York Times,* and served as a wakeup call to all fashion observers with its virtually soft-core pornography motif (fig. 8). Young girls stare into the camera or romp in a hotel room, jumping on the beds in scanty underwear for no discernible reason. The reader/voyeur is instantly drawn into a disturbing slice of narrative reproduced on the cover of the brochure: a picture of a trembling, partly naked young woman standing before her cast-off wedding gown, looking fearfully toward the hand of a man who is beyond range of the camera. The picture provided enough sexually explicit material for the laziest of imaginations. In other images, straightforward views of statuesque models are seen standing full-length against walls or lounging provocatively on beds in hotel rooms. Bourdin sometimes used a split-screen view in which one sees groups of women in two hotel rooms at the same time, contributing further to the pictures' voyeuristic theme. In effect, Bourdin was arousing the reader's impulse to become one of the characters in the sexual scenarios. It created a sensation.

Richard Avedon, an exemplar of sustained invention throughout his career, had begun using models in unglamorous and dicey settings by the late 1940s—on the street with passersby, with circus elephants, at the casino, and amid street performers. Later, he anticipated the idea of extending the narrative of the fashion photograph through a series of particularly original advertisements for Christian Dior in 1983. Dior commissioned Avedon to produce an ad campaign that would unite countless kinds of apparel and accessories produced by thirty-two manufacturers under license to Dior. Avedon conceived of the The Diors (fig. 9), a fictional trio that appeared in the series for a year. The copy, written by Doon Arbus (the daughter of the portrait photographer Diane Arbus), offered no actual story line ("When the Diors got away from it all, they brought with them nothing except 'The Decline of the West' and the butler"). But the visual consistency and soap-bubble narrative of the text held a diverse group of products together and kept the audience rapt over an extended period of time.

The relationship among The Diors (personified by model Kelly Le Brock, art dealer Vincent Vallarino, and actor/director Andre Gregory) was always ambiguous and implied a ménage à trois; part of Avedon's genius was to leave the nature of the relationships unanswered. Avedon also pioneered later devices, such as harnessing the recognition power of celebrities in advertisements, when he used look-alikes of very famous people as models in the same Dior campaign. In one of his pictures, the wedding of two of The Diors is attended by a very convincing version of Jacqueline Kennedy Onassis, as well as by the real New York television personality Gene Shalitt and the actual noted actor Ruth Gordon. In 1983, Jacqueline Onassis sued Dior for using her look-alike in Avedon's campaign without her consent, claiming that the act violated her civil rights. The alliance of fame and fashion was powerful and enduring; it later became part of the raison d'être for the magazine *In Style,* and celebrities were increasingly seen on the covers of *Vogue* and *Harper's Bazaar.*

In their day, these photographers were the fashion industry's avant-garde. By definition, they stood out from a less inventive pack; the majority of fashion photographs being made, then as now, were straightforward pictures of women with a clear view of the clothes. But over time, the avant-garde had its usual effect, as the

6. **GUY BOURDIN**. Untitled. n.d. Chromogenic color print. 7. **HANS BELLMER.** *Games of the Doll (Jeux de la Poupée).* 1949. Hand-colored gelatin silver print, 5 ¹⁄₂ x 5 ³⁄₈" (14 x 13.7 cm). The Museum of Modern Art, New York. Purchase. 8. **GUY BOURDIN.** Untitled. 1976. "Sighs and Whispers." Published in advertising insert to *The New York Times* for Bloomingdale's. 9. **RICHARD AVEDON.** *The Diors.* 1983. Advertising campaign for Christian Dior

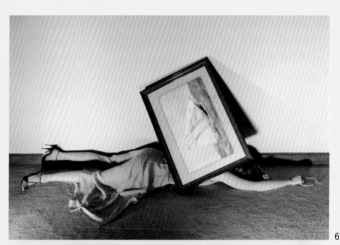

6

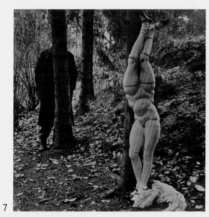

7

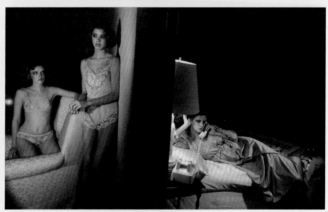

8

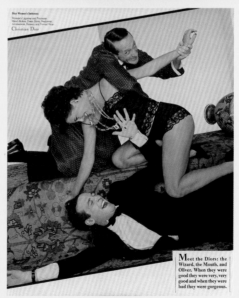

9

field of fashion photography slowly absorbed the precedents set by these earlier leaders. By 1990, sporadic but adventurous, racy, and highly individualistic bodies of work made for fifty years had coalesced into a trend that infiltrated the main body of the fashion photography world.

Antiestablishment thinking and the perspective of modern art were two of the major factors that influenced fashion's adoption of the narrative. But another great influence was the clothing itself. Although it may be difficult to perceive most of the changes in clothes made since the 1950s (and not simply because designers have so thoroughly recycled the clothing of previous decades that they've almost run out of a history upon which to draw), the expansion of the subject of fashion photography from clothing to lifestyle reflects a major change in the fashion industry itself. As it adapted to the interests and concerns of a contemporary audience, it radically broadened the range of possibilities for the photographer.

In the mid-1960s the antiestablishment clothed itself in all manner of dress, from psychedelic T-shirts and jeans to peasant blouses, while the establishment tried to join in by growing sideburns as it continued to wear precisionist Courrèges or a watered-down version of it. Couture itself was under siege, but not by the 1960s revolutionaries. It was declining because of a lack of craftsmen, who were no longer needed because of the mass production of clothes. Through long hair on women and men (ponytails not seen since the mid-nineteenth century), nighttime sunglasses (favored by the post-beatnik crowd and those pursued by the paparazzi), miniskirts, ethnic dress from India and elsewhere, and the discovery of thrift-shop "vintage" clothes, high fashion went beyond the boundaries of watered-down couture to join the Beatles, Mao, and the iconography of Pop. Mass culture had truly arrived in the world of fashion. This represented a sea change that has washed over subsequent generations of consumers, designers, and fashion photographers.

In the new world of Pop culture, the establishment itself was no longer the apogee of aspiration but had become itself no more than a consumer brand of choice. First used in extensive narrative fashion in Ralph Lauren's advertising campaigns of the late 1970s, pictures of faux upper-class lifestyles—a Long Island version of The Diors— allowed middle-class Americans to relate to the fantasy of attained material aspirations (yachts and antique cars) and social status (polo playing and life in a rambling country house) described in these ads. But this was no more than one choice among many. As always, youthful interest was more centered in the antiestablishment, which expresses itself in what youth always imagines as revolutionary free-

doms, especially those of sex and drugs, intensities of feeling that verge on oblivion and make themselves apparent in the most extreme of contemporary fashion photography known as *heroin chic*. But even here, the immense sweep of available choice had become an implicit element of the aesthetic. By the late 1980s, fashion had evolved through the surprising reappearance of ethnic clothes juxtaposed with a recycling of past fashion to an era of clear contradiction. Irony was common coin.

By the early 1990s, the idea of wearing sneakers with an evening gown or tuxedo was seen not only as acceptable but stylish. While this was fun and comfortable, it was also intriguing for its power to create the impression that the woman or man wearing such an outfit is contradictory and complex, as expressed through the medium of consumer choice. This implication of psychological complexity and lack of social snobbery indicated that the wearer's identity was intact, and above everything else, that it was *his* or *her* identity, a conscious mode of personal expression that often carried within itself the same measure of implied sexuality as Helmut Newton's stylized imagery. To wear sneakers with an evening gown is to suggest that one is feminine and masculine. To wear a denim jacket with a gauzy flower print dress suggests the same. When attractive men or women wear thick black eyeglasses straight out of the nerd community of the 1950s, it suggests that they are attractive *and* smart, or that foreign films have heavily influenced them. The irony of these fashion statements reveals a self-deprecating acknowledgement of style, but it also underlines the sovereignty of consumer choice.

Fashion and fashion snobbery still exist, but in addition to design being determined by the top labels, the consumer (or "the street") now also determines them. Young people are the largest targeted audience for consumer goods, and they wield the economic power to effectively project their ideas and preferences back to the top. The high-end designers, in turn, are more than willing to accommodate their whims, and these days are inspired by their vitality. Fashion photography logically followed increasingly idiosyncratic clothes, culture, and markets. The mass marketing of street fashion, such as low-slung baggy jeans, paradoxically helped precipitate strong narrative elements and striking imagery in fashion photography. Once again, fashion photography drew its inspiration from the world of art photography, where the same problems—the multiplicity of imagery in everyday life, the resultant exhaustion of traditional dramatic gestures, postures, and situations, and the constant jostling of diverse forms of expression—had long challenged the foundations of traditional artistic expression. In the post–Andy Warhol

art world, photographers were also making use of explicit or implied narrative techniques to augment the vitality of their work, notably, but not exclusively, in the cases of Cindy Sherman and Philip-Lorca diCorcia.

Fashion photography was quick to join in. The Gap clothing chain recently launched a mass-market advertising campaign in which models were posed in an approximation of the artist Robert Longo's prints and drawings from his well-known *Men in the Cities* series—a commentary on urban conformity (figs. 10, 11). The clothes of the Gap company, straight from the uniform factory, and those of its companion brands Banana Republic and Old Navy, among other chain stores, are manufactured for a segment of a young generation that has neither the time nor the money to think too long and hard about clothes, and their marketing requires strong advertising campaigns in order to create the appearance of individuality. Fashion had become so central that it could be used for many things, from selling cigarettes to the Benetton advertising campaigns of the early 1990s produced by art director Oliver Toscani. In those controversial campaigns, Toscani used photographs of social and political subjects, such as AIDS, race relations, and forced emigration with the Benetton brand as a mere attachment, ostensibly to precipitate a discussion about the issues (fig. 12). Although the campaign thrust the issues into the face of the reader, the controversy was less about these social and political problems than it was about the fact that Benetton dared to use such pictures to bring attention to selling clothes. The juxtaposition of devastating world problems with a brand of clothes was unseemly and troubling, but it was, nevertheless, a sensational attention-getting device. There were, literally, no bigger narratives.

Ironically, just as the narrative techniques of art photography were beginning to insinuate themselves into fashion photography, fashion was receiving recognition as a budding aspect of art. The February 1982 special issue of *Artforum* magazine featured a cover photograph of a rattan bodice and nylon polyester skirt by avant-garde Japanese designer Issey Miyake. This was the first time fashion was showcased on the cover of a contemporary art magazine. The photograph was by Eiichiro Sakata, an unknown photographer, and the point of the picture was not the photography itself, but the remarkable fashion. The editors of *Artforum* explained the union of art and commerce: "The tradition of *Artforum* is not to limit its territory to one visual world, and the borders of its coverage have fluctuated in order to maintain a fluidity toward, and a discussion of, the very definition of art, which needs to break down to affirm its

strength. One could say, in fact, that the history of this magazine lies in examining the resulting fragments. In part, this issue seeks to confront art making that retains its autonomy as it enters mass culture at the blurred boundary of art and commerce, and . . . popular art."

Since 1982, fashion has become increasingly visible on the pages of *Artforum*, as brand-name advertisements and as the subjects of articles, artwork, and exhibitions featured in the journal. The cross-fertilization of fashion and art has flourished in the last twenty years with artists such as Sylvie Fleury and Karen Kilimnik, who appropriate fashion products and imagery to question the role of consumer desires, and, more recently, Takashi Murakami, who collaborated with designer Marc Jacobs on the design for last spring's widely coveted Louis Vuitton bags. The influence of art in fashion magazines is just as vibrant, as seen in the increasing number of artists seeking the limelight in mass-consumer fashion magazines, either photographing for fashion editorials or appropriating commercial techniques of fashion photography in their own artwork.

One reason for this trend was an element of market economics. Since there was no market for the sale of photographic prints until the mid-1970s, serious photographers were obliged to find their main source of income in publishing, as many continue to do today. They found ready patrons in the publishing world. Just as Robert Frank and William Klein had worked for the fashion industry in the late 1940s and 1950s, the next generation of photographers, including Garry Winogrand and Diane Arbus, among many others, occasionally did so too. But it was primarily their competence as professional photographers, not their personal photographic interests, that the magazines and advertisers sought. While adventurous graphic designers and art directors, such as Alexey Brodovitch at *Harper's Bazaar* and Alexander Liberman at *Vogue*, understood the graphic possibilities of the 35mm black-and-white work of Frank, Klein, and others, most magazine editors were not so forward-looking.

Those attitudes changed with the emergence of a flood of independent magazines that began in the 1980s and gave a new boost to the inclusion of art photographers in the fashion field and also to fashion itself by providing opportunities for a greater variety of designers to display their wares. The clamor of competition in the mass marketplace gave even more emphasis to the new, the striking, the shocking, and the dramatic in the images that affected these trends. *Dutch, Purple, Tank, Self Service, Big, Surface,* and *Sleek* are titles of magazines founded in the 1990s that bridged the worlds of art and fashion, in part, because some of their designers and even editors were art-school graduates. The mostly European glossy lifestyle

magazines showcased young and unknown photographers and designers. Their circulation was small, and many of their runs short-lived, unlike that of the more commercially driven mainstream magazines like *Vogue* and *Harper's Bazaar*. These independent publications encouraged creativity and innovation, and fostered an artistic approach to fashion, often interspersing art within the pages of fashion editorials. Photographers, stylists, and editors for the magazines expressed ideas, constructed narratives, and made images that spoke to their own generation. Editorials were born not from trends seen on the runway, but rather from a conceptual beginning, either a literal, cinematic, or psychological impetus that made for a compelling story.

The proliferation of new magazines was not only the result of the increasing availability of desktop publishing but also of a heightened interest in fashion as a conveyor of cultural ideas, as seen in the increasingly numerous exhibitions of and about fashion in museums such as the Victoria and Albert Museum, The Metropolitan Museum of Art, and the Solomon R. Guggenheim Museum. In the February 1999 issue of the British independent magazine *Tank*, the American photographer Gregory Crewdson's photographs of staged surreal scenarios set in suburbia appear not as fashion photographs but as art that embraces the influence of film. The inclusion of art within such magazines seemed aimed at validating them as a form of art in themselves, since many of these publications were expensive and had a very limited readership. The magazines fostered an intersection for art, music, fashion, design, and youth culture, and helped usher in a boom in fashion photography that focused even further on originality and personal expression.

In London, a former art director at British *Vogue,* Terry Jones, founded *i-D* in the summer of 1980, in order to create a magazine with design and content inspired by London punk and street culture. The magazine featured gritty, straightforward black-and-white photographs of people on the street that functioned as fashion editorials, and the layouts eschewed traditional magazine design by utilizing different typefaces, ticker-tape headlines, and collaged page formats reminiscent of the small photocopied fan magazines known as *punk 'zines.* Along with *The Face,* another influential magazine launched a few months earlier, *i-D* was to become a visual diary of a new generation. During the late 1980s and early 1990s, Nick Knight, a photographer and editor at *i-D,* and Phil Bicker, the art director at *The Face,* were instrumental in encouraging photographers such as David Sims, Glen Luchford, Craig McDean, Juergen Teller, and Corinne Day to express their ideas.

Perhaps the most poignant example of art photography's influence on the independent magazines was an editorial by the photographer Mikael Jansson that ran in *Dutch* magazine in 1998. The editorial, titled "Homosapiens Modernus," featured forty pages of black-and-white photographs of nude models frolicking in the midsummer twilight of a rural Swedish landscape. Not a stitch of clothing appears in any of the photographs, but each page is accompanied by the traditional fashion credits found in all magazine editorials. The opening image, a couple holding hands under the shade of a forest, is credited to Gucci (fig. 13); a woman standing alone on a rocky beach is accompanied by the credit "Christian Lacroix"; and a man lying pensively on the grass is credited to Yves Saint Laurent. In this editorial by Jansson, a fashion photograph is defined as such only by a credit in the corner of a page. The image garners more power than the clothes themselves. The tactic of using the credit as a stand-in for fashion was first used in *Interview* magazine, which annotated each image in detail with fashion credits, even where they weren't appropriate, such as noting the brand of shoes worn on a model when it was only a torso shot.

The American counterparts to *i-D* and *The Face* were magazines like *Interview* and *Punk,* but neither of these was specifically fashion oriented. But, in 1985, the New York newspaper *The Village Voice* launched the fashion insert *View* (after the first issue, spelled *Vue*), which sought to showcase innovative photography, design, and fashion (fig. 14). Inspired by the creative laboratory that had defined Brodovitch's years at *Harper's Bazaar,* the insert's staff of four attempted to create a magazine that was driven by design and photography rather than directed by fashion and trends. It was discontinued after six issues, but the strategies employed by Mary Peacock, fashion editor, and Yolanda Cuomo, art director, presaged the thinking behind many of the independent magazines in the 1990s, and led to a greater fusion of the art and fashion photography mediums.

Partly owing to a lack of funds, but mostly because of the free rein that was afforded to the young staff, *View/Vue* did not employ established fashion photographers or feature professional models in its pages; instead, photojournalists and art photographers such as Nan Goldin, Laurie Simmons, Gilles Peress, and Philip-Lorca diCorcia brought their own art practices into the stories they made. Because *View/Vue* used art photographers and featured design as much as photography in the layouts, the editorials were infused with a creative punch and freedom from fashion photography's commercial standards, which had come to characterize some of the innovative fashion magazines of the 1990s.

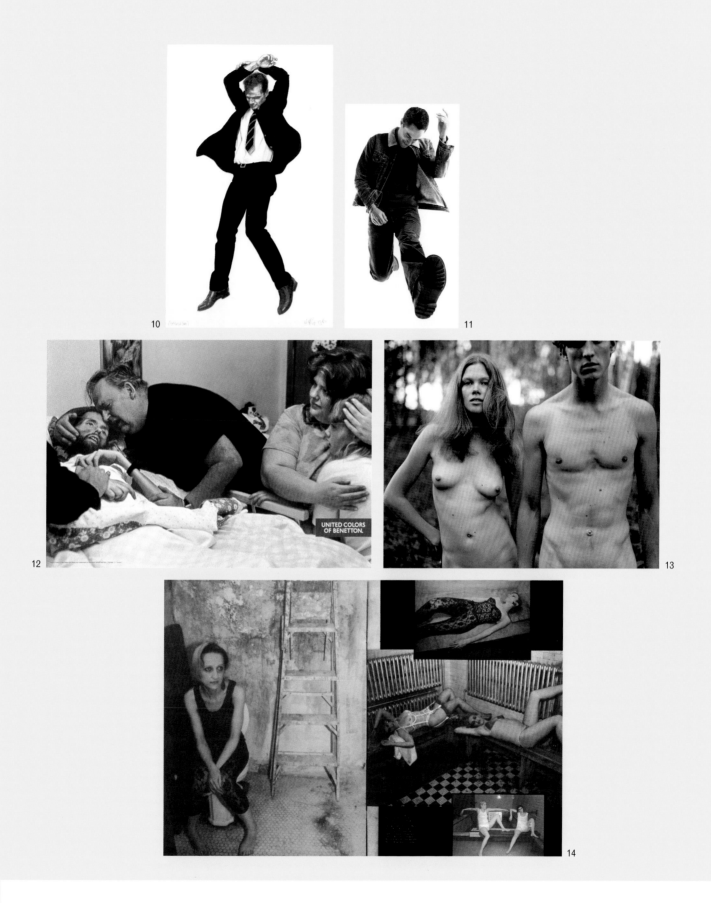

10. **ROBERT LONGO.** Untitled, from the series *Men in the Cities*. 1981–87. Charcoal, graphite, and ink on paper, 50 x 30" (127 x 76.2 cm). The Museum of Modern Art, New York. Gift of an anonymous donor. **11.** Gap advertising campaign, Fall 2003. Photograph by Mikael Jansson. **12.** Benetton advertising campaign, 1992. Photograph by Therese Frare; concept by Oliver Toscani. **13. MIKAEL JANSSON.** Untitled, from the editorial "Homosapiens Modernus," *Dutch*, no. 18, 1998. **14.** Layout from the editorial "Masculine/Feminine," *View* (Supplement to *The Village Voice*), 1985. Photographs by Nan Goldin

The prevalence of narrative in fashion photography leads to another, enormously influential aspect of the medium: cinema. Ever since the pioneering work of Eadweard Muybridge and Étienne Marey at the turn of the nineteenth century, the link between the two art forms has been explicit. With the abandonment of the portrait as the main focus of photographic expression, almost all photographs can be thought of as frames from a film, a time-stopped element of a story. Film is also a popular language, perhaps the most popular language of the twentieth century. It was inevitable that both art and fashion photography, growing ever more related, should also begin to appropriate the imagery and narrative constructions of their more powerful cousin—just as, in previous eras, the visual arts based their imagery in the narrative tales of the Bible, the classics, and heroic literature. For fashion photography, in particular, the impulse to appropriate imagery and narratives from the movies was also grounded in the glamour that was explicitly created by the moving medium. Glamour and melodrama, the chief sources of cinema's mass appeal, became a kind of visual short-hand that fashion photography could easily appropriate to amplify the impact of its own narratives. Thus, characters from Hollywood films, especially those of the 1950s and 1960s by Alfred Hitchcock, and the films by French director Jean-Luc Godard and Italian director Michelangelo Antonioni are continually recycled in fashion photography. In the cinematic fashion photograph, the glamour of movies is joined with the glamour of fashion.

Ironically, this has brought back the importance of the studio system, but with a different twist. With the advent, in the 1970s, of narrative subjects created by art photographers in the studio, the photographer became a kind of film director. Sets were constructed as backgrounds for narratives, models and friends enlisted as subjects, and lighting specialists were called in. This retreat to the studio was part of an artistic impulse in the broader community that was based on the justified suspicion of photography as being a truth teller and on an intellectual investigation of photographs as purveyors of culture.

The *Untitled Film Stills* created by Cindy Sherman (fig. 15) in 1977–80 began as simple black-and-white 35mm photographs taken after Sherman had transformed herself into imagined film characters. While Sherman did this work alone, with the occasional assistance of a friend or family member, other photographers began to enlist crews of people to help out. The clearest example of such cinematic methodology applied to still photography can be seen in the work of Gregory Crewdson, as seen in his series *Natural Wonder* (fig. 16) and in his

more recent photographic tableaux in which he used noted film stars as the protagonists in images created to appear as if they were scenes from movies. Crewdson's work exploits the fact that what is left out of the frame of a photograph is as important to the viewer's experience as what is in the frame. To secretly enter a narrative over which we have no control, except for the imagination we bring to it, further instigates the impulse to fantasize without repercussions, and the story happening outside the frame underscores our voyeuristic sense because the voyeur is always at a tantalizing disadvantage.

The cinematic techniques adopted by contemporary fashion photographers range from the actual scripting of stories with fully drawn characters to the use of lighting and camera angles normally used by filmmakers. The magazine format offers the photographer the opportunity for an extended narrative over a number of pages; this means that a telling detail, a lingering camera shot of an object, or a person leaving a room, suggests a more detailed narrative to be completed by the viewer. The same holds true for artists who have appropriated film and its culturally powerful signifiers since the late 1960s. For example, in *The Telephone Book (with pearls)* John Baldessari compiled cropped stills from 1950s black-and-white movies, all of which included views of telephones or pearl necklaces (fig. 17). The book evokes humor because of its obviousness, anxiety because we don't know what's going on in each picture as it is cropped, and commentary on the continued use of dramatic apparatus and signifiers as vivid but enigmatic clues.

Perhaps the best-known contemporary exemplar of the fusion of self-conscious cinematic technique with photography is Philip-Lorca diCorcia. He is recognized internationally as a photographer who has exhibited and published his work for more than twenty years, and as an artist who has influenced a subsequent generation of image-makers. DiCorcia's personal style of picture making emerged after he graduated from Yale University's two-year M.F.A. program, which was steeped in photographic history but lacked an interdisciplinary approach. With his historical perspective, diCorcia understood that to create works that were genuinely new did not require him to apply the pyrotechnics of intellectual theory but, rather, to distill the culture that had most profoundly influenced him. This was primarily cinema, which he mixed with photographic history into a brew that applied cinematic narrative to the ever-inspirational incidents of quotidian life.

DiCorcia's photographs have always been carefully planned images that combine the seductive powers of cinematic and commercial photography with a deeply felt perception of the possibilities

of meaning in the prosaic: how the ordinary can become exceptional when framed with the right amount of intelligence and imagination. DiCorcia is a member of a generation that watched movies when the hyperbolic dramas of Douglas Sirk and camp classics such as *Valley of the Dolls* were shown along with the postwar foreign films of Roberto Rossellini, Federico Fellini, Ingmar Bergman, and Jean-Luc Godard. The intellectual, emotional, and, most significantly, visual impact of these films replaced the literary influence of books and the history of art as formative elements in a new photographic vocabulary with which many contemporary photographers would subsequently work.

The fashion photographs of diCorcia are cryptic moments from a narrative that has no beginning or end. His "Cuba Libre" portfolio (pages 42–53) appeared in *W* magazine as a thirty-page photographic essay in 2000. The story opens with a panoramic overview of Havana, such as one might see in a film flavored by its locale. The protagonist is a woman alone, and a clandestine current of repression dominates the scene, athough the explicit plot of the narrative is never revealed. Its essence is pure intrigue and melodrama, without apparent beginning, middle, or end.

DiCorcia's voyeuristic views often describe people (most often alienated women) who live in existential despair. The surfaces of the pictures are seductive; their lights and darks, through the advantage of digital printing where color is seen even in the blacks (another similarity to cinema), achieve an atmosphere of morbidity in which the characters are trapped.

What diCorcia does explicitly, other photographers have done more elliptically. Cedric Buchet's ethereal overhead photographs, shot by a camera on a high crane, resemble the landscape and mysterious encounters of Federico Fellini's 1963 film *8 1/2*, even while displaying "characters" dressed in Prada clothes (pages 34–41). In *8 1/2* Fellini is portrayed by Marcello Mastroianni: a successful and prominent filmmaker, he is alternately accosted and soothed by a crowd of producers, friends, wives, family, and mistresses as he struggles to make his next film. Several times in the film we see the central figure wandering aimlessly through a veritable fog from which living and dead characters mysteriously appear—offering solace, advice, memories, and taunts—and then disappear (fig. 18). Buchet's overhead views were printed as two-page spreads to accommodate the scope of the images. The photographs invite us to linger in spaces swathed in transcendent light and in the absolute neutrality of a scene, which allows us to look carefully at the clothes. The pictures describe a world of shifting characters in beach scenes that embody both the

real (conscious) and the dreamed (unconscious). Protagonists, faceless for the most part, cross paths dressed in Prada's newest designs, and when full-figured characters appear they project the energy of robotic puppets. With Buchet, the reference is not only to cinema but, as with Fellini, to the surreal. Although Buchet was not aware of it, his Prada campaign of 2001 bears an uncanny, but superficial, resemblance to photographs by Munkacsi (fig. 19) that were reproduced in *BIZ* in 1929. We are not always aware of the pool of images in which we swim, but their effect, while unconscious, is indelible.

Another artist whose explicitly cinematic references have profoundly affected fashion photography is Cindy Sherman. The master of knowing disguise, Sherman (pages 54–61) was commissioned by the adventurous designers Dorothée Bis and Rei Kwanakubo of Comme des Garçons to produce photographs for their campaigns of 1984 and 1994. Sherman was the perfect choice for two designers whose own work stretches the limits of fashion design with an uncommon fearlessness. It is no surprise that the resulting photographs are a send-up of the entire idea of fashion, just as Sherman's groundbreaking *Untitled Film Stills* (1977–80) critiques the roles women play in society as described by movies. The characters that Sherman created for the designers were horror-film harridans who are the ultimate victims of fashion. Their psyches have been damaged, and it appears that fashion (given the context of the work) is the perpetrator of the damage. Her fashion photographs seem to be saying that no matter what you wear in your fantasies, the unattractive part of you will never go away: in fact, it will finally dominate the guise you create.

The potential strangeness lurking beneath the surface of our lives was described for three decades of postwar Americans by David Lynch's 1986 film *Blue Velvet*. The movie, influenced by 1940s film noir, 1950s B-movies, and art films, is a mystery/suspense drama set in a small American town. The photography in the film contrasts an unnatural brilliance in daytime with scenes photographed at night, where details revealed in the shadows heighten our sense that something hidden and foreboding lurks beneath the surface—even in the sunshine. In his 1997 and 1998 campaigns for Prada, British photographer Glen Luchford translates the dark side of *Blue Velvet* into provocative stills from an extended cinematic narrative that is filled with tension and ambiguity (pages 68–75). These photographs were made during a time when a palpable feeling of change hung in the air, resulting in the rise of new kinds of fashion imagery. Creativity was not only encouraged, but demanded by avant-garde magazines such as *The Face* and *i-D*, and bigger publications like *W* and *Vogue Hommes*, which were seeking fashion imagery that went beyond

15. CINDY SHERMAN. *Untitled Film Still #54*. 1980. Gelatin silver print, 6 ¹³/₁₆ x 9 ⁷/₁₆" (17.3 x 24 cm). The Museum of Modern Art, New York. Purchase.
16. GREGORY CREWDSON. *Untitled*, from the series *Natural Wonder*. 1988. Chromogenic color print (Ektacolor), 26 ³/₈ x 37 ³/₄" (67 x 95.9 cm). The Museum of Modern Art, New York. Purchased as the gift of Barbara Jakobson. **17. JOHN BALDESSARI.** Untitled, from *The Telephone Book (with pearls)*. 1995. The Museum of Modern Art Library, New York. **18. FEDERICO FELLINI.** Film still from *8 ¹/₂*. 1963. **19. MARTIN MUNKACSI.** *Beautiful Autumn, the Last Warm Sun Rays*. Published on the cover of *Berliner Illustrirte Zeitung*, September 29, 1929

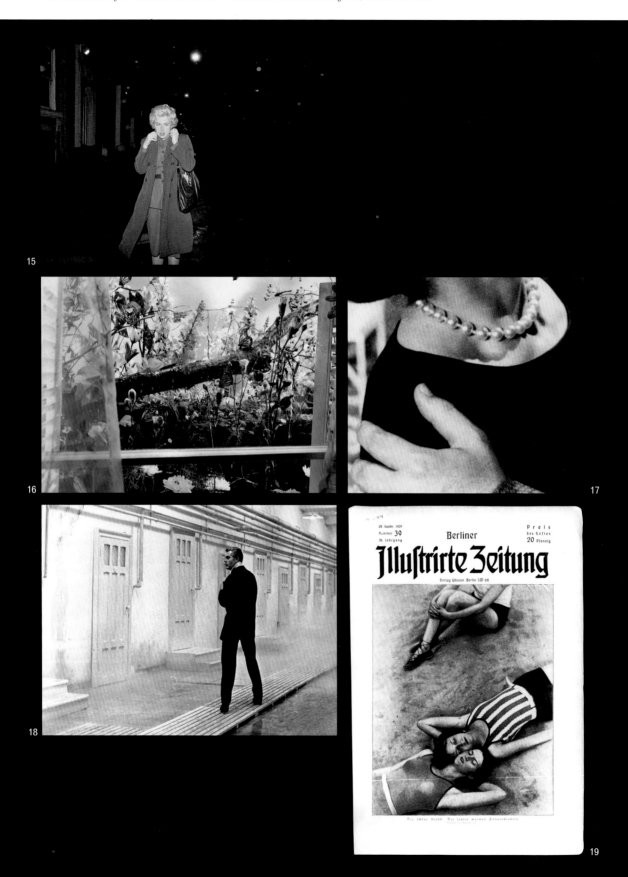

showcasing beautiful clothes and models to actually provide an aesthetic, cultural, and emotional impact on the audience.

Glen Luchford started working in the early 1990s, at a time when British fashion photography embodied the adventurous and creative. Photographers such as David Sims, Corinne Day, and Craig McDean were all working during this time at the same lab in London, encouraging dialogue, camaraderie, and shared interests. Nick Knight was the editor for i-D magazine and hired photographers Nigel Shafran and Craig McDean; and art director Phil Bicker at The Face fulfilled the same role by giving unknown photographers Corinne Day and David Sims their first jobs, encouraging both with an atmosphere of complete freedom. Stylists such as Alexandra White and Melanie Ward also worked with the same group of photographers to create images that felt fresh and new, and were soon co-opted by the mainstream magazines and other photographers. This change was influenced in part by the predominant grunge and rave culture in Britain at the time, which changed people's attitudes toward dressing, de-emphasizing the importance of head-to-toe outfits and style dictated by commercial fashion brands. In turn, the personalized and individual interpretation of fashion transformed the images of fashion. Personal expression became more important than actual clothes, and independent start-up magazines such as Purple, Self Service, and Dutch all contributed to this shifting definition of fashion. It is during this period that Luchford made some of his first images, ones rife with tension, eroticism, and theatricality that challenged the delineation between fact and fiction, using fashion as a mere prop in these dramas.

In most of Luchford's pictures for the Prada campaigns, only parts of bodies or figures are seen. The photographs are cinematically lit, and the ambient light, sets, props, and careful framing create a claustrophobic environment imbued with the mystery of film noir. In one image a woman fearfully looks back over her shoulder as if someone is lurking in the shadows of the room. In another, the model sits on the ledge of a building, as if she is contemplating slipping off the rain-slicked edge. In another photograph made for the 1997 campaign, a woman's illuminated legs with the red ribbon of her shoes tied suggestively around her ankles lie lifeless on the damp and murky grass, leaving viewers to draw their own conclusions about her unfortunate end. Luchford's images propose a way to address concerns beyond the synthetic surface of fashion by utilizing cinematic strategies to heighten a complex psychological and emotional state.

For more than twenty-five years, Ellen von Unwerth has celebrated movies through her fashion photography. Her photographs are generally straightforward, without special effects or the allusion to a more complicated narrative; she simply uses characters from noted films as the protagonists of her fashion essays, such as the piece for the October 1990 issue of Vogue in which models are used to reincarnate Jean Seberg and Jean-Paul Belmondo in Jean-Luc Godard's New Wave counterculture film Breathless (1959). Von Unwerth's fashion essay concentrates on the breezy life of the doomed lovers as they tool around Paris riding a motor scooter, smoke at cafés, and snuggle in bed. Von Unwerth exploits readers' identification with the characters in the film, especially the generation that came of age in the 1960s, when European culture and a bohemian antiestablishment lifestyle were the vogue. More specifically, the New Wave French films radically changed the way movies were made. They were consonant with the disjunctive and nonlinear literature of the time. Their off-beat characters (often based on American movie gangsters) and the details of their behavior and dress helped create an identity for members of the American counterculture.

The photographs that von Unwerth made for Alberta Ferretti in 1995 (pages 62–67) depict a modified version of Hollywood's classic blonde starlet, tracked by an omnipresent photographer as she goes about ordinary activities. The series draws us into several layers of popular culture, beginning, of course, with the starlet, a type familiar to us through fan magazines and films. As in Cindy Sherman's Untitled Film Stills, she is a character on whom we project countless associations we have learned through movies. In this case, we cannot help but immediately identify her with the tragic life of Marilyn Monroe—the star as victim, even if it is a cliché. We are voyeurs, "seeing" the "starlet" in her "private" life, as she might be photographed by paparazzi, or by a photographer commissioned to follow the actress through a day, perhaps while on a press junket for a new film. There are similar views within Sherman's Untitled Film Stills series. Von Unwerth's use of black-and-white film also evokes the Sherman series and real film stills, and the gestures of the "actress" refer to the clichés reserved for such photo-essays, and Sherman's stills. As Don DeLillo recently wrote in an essay on the lingering effect of films: "Movies can shape a layer of memory, leading us into a shared past, sometimes false, dreamlike, childlike, but a past that we've all agreed to inhabit."

The cinematic tendency in fashion

photography represents what might be called the public aspect of modern photography—the aspect that is in play in our representation of others. But there is another tendency in photography that has come to exercise a dominant if paradoxical influence on both art and fashion photography: the private aspect. It derives from the vast

realm of images that were not taken with the objective of public display in mind. Their birthplace is the snapshot and the family album.

"Of all photographic images, [the snapshot] comes closest to the truth," declared the photographer Lisette Model. For her, as for many others, the candid family snapshot is understood as casual, innocent, and unorchestrated, capturing life and people as they really are, devoid of pretension and constructions that appear to bind it to art or studio photography. The snapshot promises to relive the moment in which it is taken, whether a wedding, new baby, or vacation, and often depicts the subject closest to our hearts: family. It is oblivious to the rules of serious photography, so that its subject matter, which is usually centered in the frame, is more crucial than original composition, accurate color, and print quality. With its apparent access to emotional immediacy, the snapshot engendered family albums, visual diaries, and scrapbooks, and in these volumes we find domestic interactions and treasured moments.

The family photographs that we cherish today arise from two distinct photographic traditions: the formally posed nineteenth-century studio portrait and the spontaneous images derived from the Kodak Brownie and the 35mm tradition that took advantage of the mobility of the hand-held camera. Both kinds of photographs, however, are beloved keepsakes that privately track our personal histories and memories of some of the most important milestones of our lives.

The stiff frontal posing of the studio portrait still dominates many family photographs today, whether it is a class portrait or an image of a child standing proudly in front of a new bike. While family photographs allege honesty, the highly stylized pictures that are often taken do not necessarily memorialize an event truthfully. As if on instinct, even the most recalcitrant twelve-year-old will smile for a split second when the camera clicks, before slumping back in boredom in his or her seat at a particularly long Thanksgiving dinner. This presentation for the camera is a cultural ritual in which families participate year after year, and points to the complexity of the layers of meaning in the autobiographical picture.

Unlike posed family portraits, the casual snapshots in family albums and scrapbooks capture events as they are experienced. As with all modes of photography throughout the medium's history, technology determined the development of the snapshot. Hand-held cameras in the first half of the last century still required attention to composition and lighting, and knowledge of the rules of exposure. It was through the development of mass-marketed automatic cameras with auto-focus, auto-flash, and internal automatic light meters that amateur photography proliferated. Such innovations, as well as the advent of disposable and digital cameras, have made it increasingly possible to capture moments spontaneously as they unfold.

The snapshot's emotional authenticity and the degree of empathy it inspires between the viewer and the subject have made it attractive to art and fashion photographers alike. Amid the clamor of commercial imagery, the possible ties that bind the viewer to a memory—real or false—of the subject are powerful and intriguing tools of perception, with multiplying ramifications. In a generation of photographers who grew up surrounded by such photographs, the possibilities were not going to be ignored.

Thus, by 1990, the snapshot and family album aesthetic came to inspire fashion photography almost as much as the cult of cinema did. The inspiration came in two forms: posed and candid. When posed, the snapshot recalls ritualistic moments and perfected scenarios of family interaction, while the candid snapshot introduces a sense of reality or authenticity to the magazine page.

The line between casual amateur and skilled commercial photographer is often intentionally blurred in 1990s fashion imagery. Photographers emulating the snapshot deliberately avoid the studio and requisite lighting employed by Penn and Avedon, and instead opt to make photographs that are, or appear to be, autobiographical and uncontrived. Some contemporary photographers started using point-and-shoot cameras to capture friends, family, and real-life situations, unobtrusively—fashion as it is lived. The spontaneity that characterizes their work harkens back to photographers who took to the streets to make pictures that blended reportage and fashion, among them Martin Munkacsi, William Klein, and Jeanloup Sieff.

In the 1990s, photographers such as Corinne Day, Juergen Teller, Mario Sorrenti, and Terry Richardson regularly photographed their friends and lovers in "real-life" situations for fashion magazines. As a consequence of Corinne Day's controversial photographs of the unknown skinny teenager Kate Moss in British *Vogue* in 1993, the unfortunate terms *waif* and *heroin chic* became household expressions. This new direction in fashion photography celebrated not just untraditional beauty, but sometimes featured downright ugly scenarios. As the snapshot aesthetic took deeper hold, images of very thin models with greasy hair and sallow skin lounging in rooms littered with cigarette butts, dirty carpets, and beer-stained couches became points of controversy in a broader social context. Conservative critics alleged that they offered thinly veiled references to drug use and glamorized unhealthy lifestyles. But the real point was different and paradoxical: fashion photography was presenting itself as bypassing fashion photography.

As part of this turn of events, models began to be cast from real life and from the street, and the credit line "clothes model's own" became commonplace on the magazine page. Not only were the models and narratives atypical, but the photographs themselves often did not adhere to technical rules of good lighting, focus, or cropping, thereby aligning them further with amateur snapshots. The images were read as subversive and authentic challenges to the conventions of the fashion image, and as introducing "realism" into a glamorous genre. They acknowledge not only Nan Goldin's slide show *The Ballad of Sexual Dependency* (first shown in 1979) but also Larry Clark's *Tulsa* (1970) (fig. 20), an autobiographical book of photographs of the author's drug-addicted friends and their lifestyle. Yet the new "spontaneous" photographs were as fabricated as any other fashion images of a previous age, and inevitably became as mannered and self-conscious as the studio portraits they were replacing.

The appropriation of the snapshot aesthetic in the 1990s was paralleled by a rise in deconstructed clothes and the resurgence of vintage fashion, which champion a more individualized expression of style. In opposition to the label-conscious 1980s, mixing and matching high-end labels with department-store brands became commonplace, even in the most commercial magazines that emphasized the selection of clothes as an important symbol of personal style. Simultaneously, street style and music influenced the vocabulary of haute couture more than ever.

Not surprisingly, the punk-influenced anti-aesthetic of autobiographical snapshots had become glamorous by the mid-1990s. The style was quickly emulated in many magazines, and what was supposedly an authentic moment became a cliché. Steven Meisel's infamous 1995 Calvin Klein Jeans ad campaign, shot in an amateur snapshot style, was contrived. The images, which were pulled from circulation because of accusations that they validated child pornography, featured bare-chested and fresh-faced young men, and innocent looking doe-eyed women, lounging in jeans or underwear in a wood-paneled room with 1970s shag carpets. The models played characters in an amateur photo shoot that promulgated underage sexuality.

In 1985 a precedent was set for this new direction in fashion photography that would become commonplace by the mid-1990s. Nan Goldin's shockingly unglamorous and straightforward photographs of four women in lingerie, taken in the Russian Baths on New York's Lower East Side, presages the snapshot aesthetic of many 1990s fashion images. Goldin's editorial, "Masculine/Feminine" (the title of Jean-Luc Godard's 1966 film), was published in 1985 in the "High/Low" themed premier issue of *View*. The women showed

simple cotton briefs and tank tops (masculine) as well as flirty lacy lingerie (feminine) while lounging around the deteriorating stone benches and tiled pools of the bathhouse, seemingly indifferent to the camera that documented them. The pictures share a snapshot aesthetic, as the lighting is amateur, the framing is loose, and the models rarely pose and smile for the camera (pages 86–93).

Deborah Turbeville's 1975 soft-focus bathhouse photographs for *Vogue* became somewhat of a benchmark in fashion photography, when they were accused of creating a "great scandal" by taking the model out of the glossy studio and inserting her in a moody scenario with intimate undertones of sexuality (fig. 21). While the narrative is similar to "Masculine/Feminine," the artistic look of Turbeville's influential editorial contrasts with Goldin's photographs. Turbeville's images are carefully posed and artfully constructed shots of professional models, while Goldin's more straightforward pictures resemble casual snapshots. Reportage, art, and fashion are blurred in Goldin's images, which have more in common with personal mementos than stylized fashion images.

View was printed on traditional large-format newsprint, so that "Masculine/Feminine" is distinctly unglossy, both in its printing and imagery. Goldin's pictures are decidedly unpretentious, and the decrepit locale and low-quality printing add to the grittiness of the images. The models are Goldin's friends, and the relationships among the women, rather than any idealized notion of beauty, are the central focus of the photographs. In effect, the clothes are held hostage to the pictures—a fresh way to define and sell fashion. This approach was possible in a publication like *View*, which did not need to pander to high-end clothing advertisers and well-to-do purveyors of style, but rather to its existing readership, which was by and large young and followed the art and music scene of New York's East Village.

Unlike traditional fashion photography in women's magazines, where one image usually fills an entire glossy page, the *View* layout featured Goldin's photographs in varying sizes, often overlapping, and allowing only two images in the editorial to bleed to the full page (see fig. 14). The layout is similar to that of a scrapbook or personal album. One of the largest photographs is of a very pregnant blonde woman in a gold bra and panty set, and this untraditional underwear model turns the lure of a lingerie shoot on its head. Instead of posing seductively for the camera, she looks down as she fiddles with her bra, her panties almost hidden under her swollen belly, a surprising picture of womanly sensuality. The lingerie is not sexed up, but matter of fact, suggesting that a fashion photograph can simply be defined by the credits that identify the brand of clothing worn by the model. In Goldin's images, a

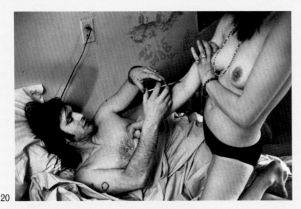

20

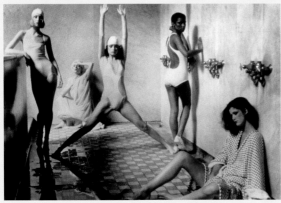

21

fashion photograph is just somebody wearing clothes, with no need for professional models or elaborate sets, and the resulting picture is just as persuasive, if not more so, to potential consumers.

Some of the photographs taken for *View* were included in Goldin's seminal autobiographical slide show, *The Ballad of Sexual Dependency*, and reproduced in the eponymous book published by Aperture in 1986. Like the *View* editorial, *The Ballad* depicts a shared experience of a specific cultural and aesthetic moment of the late 1970s and early 1980s that rejects the compression of experience into a single perfected image. The inclusion of the bathhouse photographs in Goldin's book further blurs the distinctions between art and fashion because the context suggests a validation of the fashion photograph, now disguised as a snapshot, as an artistic expression.

Another photographer inspired by the autobiographical picture is Mario Sorrenti, who became known at a young age for his Calvin Klein Obsession ad campaign in 1992, which featured a nude young Kate Moss in an idyllic beach setting, photographed in luscious black and white. Because Sorrenti was involved with Moss at the time, the photographs also function as intimate snapshots of a relationship and particular moment in his life. Although Sorrenti has subsequently photographed in many differing styles, documenting his life and friends remains at the core of his practice. In his editorials and diaries, fashion is an appendage to a certain lifestyle rather than the subject of the photographs.

At the beginning of his career, Sorrenti carried a 35mm camera with him at all times. Because he couldn't afford to print the frames he took, he cut up contact sheets and stuck them in his diary, a constant source of inspiration that has subsequently influenced the design and content of a number of fashion features, which maintain the same forthright appearance as his diaries (pages 78–79, 84–85). The subjects in his essay "One," published in *Another Magazine* in 2001, are not beautiful women but, instead, a wheelchair-bound boy smoking a bong in a graffiti-plastered room, and a band practicing in a dark and cluttered apartment (pages 80–83). Sorrenti is actually featured in several of the photographs, adding to the illusion that they offer an authentic moment or experience, rather than merely sell a product.

Juergen Teller is another photographer who uses our belief in the authenticity of the snapshot to create narrative tension in his fashion work (pages 112–119). Perhaps best known in the fashion arena for his pictures of the film director Sofia Coppola for the Marc Jacobs ad campaigns of the late 1990s, Teller meshes spontaneous moments captured on film with carefully constructed scenarios that appear to be casual. For an editorial titled "The Clients," in the March 1999 issue

of *W* magazine, Teller photographed some of haute couture's biggest clients, such as Princess Marie-Chantal of Greece and Vicomtesse Jacqueline de Ribes. Teller photographed the women at the fashion designers' Paris ateliers in the expensive clothes they bought there. These wealthy women are not the idealized beauties we regularly see modeling garments on the pages of magazines, and Teller's pictures of the clients are straightforward and uncontrived. He used a 35mm auto-focus point-and-shoot camera to photograph each woman quickly and efficiently in markedly mundane environments. Because of his bright flash and lack of retouching, the results are startlingly honest and blunt, not always portraying the women in the most flattering light. The pictures are by no means banal; instead, they communicate a frankness that reveals Teller's sharp sensibility for composition and humor. As viewers, we feel as though we might be in the room with these women, that perhaps we ourselves could have taken this picture, and that just maybe this fantasy of beautiful clothes is not so far removed from our own experience of life.

Similar in sensibility is Simon Leigh's 2002 beauty feature "Oh de Toilette" made for *Tank* magazine (pages 94–99). Witty and gritty at the same time, the photographs feature high-end beauty products that have fallen behind sinks, are wedged between radiators, and sit precariously on the edge of a cracked tub. These products are irreverently photographed, as if documenting a woman's bathroom after she has rushed to work or dashed off for a date. Leigh used available light in commonplace bathrooms. This constructed indifference toward the polished product in Leigh's images challenges more traditional beauty-product photographs, such as Penn's wonderfully clean and slick advertisements for Clinique beauty products, which are carefully composed and expertly lit.

The conventions of the family photo album also play a strong role in fashion images and stories made during the 1990s. Well-known art photographers Larry Sultan and Tina Barney used the format of the magazine to create narratives reminiscent of images in family albums. Sultan's photographs for the Kate Spade 2002 fall/winter campaign embody frozen moments of idealized domestic interactions. They take advantage of the artifice of fashion to create exaggerated narratives that address domestic conventions of family harmony or the promise of suburbia, while Barney incorporates the tradition of the family photograph to explore contemporary versions of domesticity.

Sultan's photographs for the Kate Spade campaign, *Visiting Tennessee*, are about an American upper-middle-class family's trip to New York to visit their young adult daughter Tennessee (pages 120–127). The images are placed on a white page, mimicking the for-

mat of a photo album of a family's adventures on their annual trip to the Big Apple. The Lawrences, a culturally sophisticated and stylish family supposedly hailing from Chicago, are hyper-real, photographed in glorious Technicolor, and presented in a succession of frozen moments to which we can all relate. We follow them as they check into New York's Carlyle Hotel, trek through Chelsea art galleries, shop in Chinatown, and finally enjoy a nightcap back in their well-appointed hotel room. The Lawrences are portrayed as the model American nuclear family, and the images are reminiscent of 1940s Kodak advertisements made by Edward Steichen or Ralph Bartholomew, Jr., which similarly featured highly stylized domestic scenarios (fig. 22). In the images, the characters are perfectly pulled together in the way they could be only if attended to by make-up artists and stylists.

Larry Sultan is a photographer best known for his project *Pictures from Home* (1983–92), which follows the life of his parents through photographs taken over many years. A member of the postwar baby-boom generation, Sultan documented his parents in an attempt to come to terms with a childhood defined by an American Dream consistently represented in the media as a traditional white family living a blissful, materially driven suburban existence with a domestic mother, working father, and 2.2 children. *Pictures from Home* includes photographs of his parents performing their daily rituals, details of their personal belongings, as well as stills appropriated from 8mm home movies made between 1943 and 1972. The project was published in a book, which included interviews with his parents as well as old photographs and documents from their personal and familial histories. Inspired by *Pictures from Home*, Kate Spade's creative directors asked Sultan to make similar photographs of their fictional family. The campaign's punchy color and graphic framing are reminiscent of Sultan's earlier art project, and similarly addresses the schism between memories as informed by family photographs and lived reality.

But this was a schism based in unreality. The creative directors of Kate Spade constructed a narrative and wrote elaborate character treatments for each family member and scenario that played out in front of Sultan's camera. The character treatments are similar to ones written for films. The characters are not professional models, and while they are good-looking, they are not perfect, thus heightening the sense that this is an "authentic" family album. Each character's personality is specifically articulated through personal style and clothes, and the attention to detail is evident in the elaborate props and locations. For the campaign, Kate Spade hired stylist Karen Patch, costume

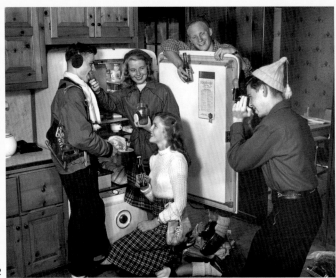

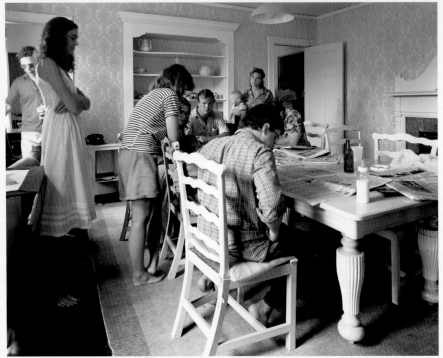

22. RALPH BARTHOLOMEW, JR. Untitled. c. 1948–56. Gelatin silver print, 15 3/8 x 19 1/2" (39.2 x 49.5 cm). The Museum of Modern Art, New York. Purchased as the gift of John C. Waddell. **23. BOB BEERMAN.** *Betty Hutton and Husband Ted Briskin at Home.* 1948. Silver dye bleach print (Cibachrome), printed 1982, 17 5/8 x 22 1/2" (44.8 x 57.2 cm). The Museum of Modern Art, New York. Gift of Marvin Heiferman. **24. TINA BARNEY.** *Sunday New York Times.* 1982. Chromogenic color print (Ektacolor), 47 1/2 x 60 7/8" (120.7 x 154.8 cm). The Museum of Modern Art, New York. Anonymous gift

designer for Wes Anderson's films, including *Rushmore* (1998) and *The Royal Tenenbaums* (2001), which share a similar sensibility in the emphasis on the expression of persona through clothing.

By contrast, Steven Meisel's editorial "The Good Life," in the October 1997 issue of *Vogue Italia*, also depicts an idealized family in a tastefully coordinated home, interacting in stereotypical familial situations, but from a more obviously contrived angle (pages 106–111). The clothes, sets, and props are carefully constructed to reflect the clichés of domestic bliss, such as family picnics and hot chocolates around the fire. Unlike Sultan's photographs for Kate Spade, Meisel's images are immediately perceived as fake, or constructed, and are reminiscent of publicity or advertising images (fig. 23) celebrating the ideal of domesticity, rather than the reality. The photographs make no attempt at authenticity, as the colors are over-saturated, the poses stiff, and the hair and make-up too perfect. Meisel creates mundane scenarios teeming with fakery, as in Douglas Sirk films of the 1950s: environments that were laden with symbolism and dramatized domestic narratives through very carefully crafted music, lighting, decor, and costume. Similarly, "The Good Life" is tinged with an undercurrent of melodrama, where over-the-top perfection becomes ironic when presented in a contemporary context already bombarded with similar archetypal visual cues. In Meisel's pictures, the narrative takes precedence over the clothes, which function as props in his tableaux. Meisel uses the rich visual language of the family album to cast the clothes as he does his characters, endowing them with personalities, life, and style all their own.

The narrative and look of Sultan's and Meisel's photographs suggest nostalgia for a happier and less complicated era. The images are iconic and present a family that is familiar yet unattainable. Similarly, the over-saturated colors in Sultan's and Meisel's photographs veer toward kitsch, and the pictured moments are clichéd to the point of being archetypal, creating scenarios that are no longer real, but exaggerated constructions of authentic encounters. Both Sultan's and Meisel's images affirm and recognize their own commerciality, and point to the constructed nature and essential falsity of such representations and longings for the "good life."

Acclaimed photographer Tina Barney uses the family-photograph motif as a tool for illustrating stories rife with the complexities and tensions that plague all families (pages 100–105). Her pictures provide intimate insider views of the world in which she grew up—a privileged circle of wealthy East Coast families. Her family scenarios are autobiographical and feature her parents, siblings, and friends, and illustrate typical domestic events such as Sunday brunch (fig. 24). The photographs are partly staged or contrived, but are born from everyday exchanges between family members. While Barney employs her friends and family, they play characters revealing domestic interactions that suggest undercurrents of malaise. Barney's prints are big, often up to five feet in length, and the large-format four-by-five camera she uses reveals each detail in utmost clarity, so that every nuance in gesture, pose, decor, and dress affects how the viewers read the relationships among the people in the photographs.

In her fashion work, Barney composes similar family narratives and scenarios. For her magazine editorial in October 1999, "New York Stories," Barney photographed some of the city's well-known cultured residents, such as the writer Joan Didion, and the families of painter Brice Marden and gallery owner Angela Westwater. Like her artwork, these photographs provide a glimpse into a world few ordinary people see. But unlike Barney's large photographic prints, the magazine editorial is on a smaller scale, creating a sense of intimacy embodied in family albums. In the photographs, fashion is an accessory, just like the sofas, art, and lamps that decorate the environments, a prop to further illustrate the stories. The families are posed, so that what once might have been a spontaneous moment of a mother holding out her hand to her young child (as in the photograph of actor Julianne Moore's family) becomes frozen. Every photograph is carefully arranged to communicate a narrative, but a flick of the head or a statement caught in mid-sentence belies the constructed story and works within the conventions of the impromptu family snapshot. The viewer becomes entrenched in the dramas and the complex relationships among family members and does not focus on the clothes.

Fashion photography in the 1990s is marked

by a desire to communicate narratives outside the world of fashion. Adopting the aesthetics of cinema and of snapshots and cherished family photographs represents an attempt by practicing photographers and editors to enrich their images with a resonance and meaning that address the concerns, desires, and realities of youth culture. More than ever, fashion photographs no longer function solely to dictate hemlines and silhouettes, but also to acknowledge their position as vehicles for an expression of cultural attitudes. Whether candid or staged, the snapshot and family album motif and the cinematic picture demonstrate that these fashionable fictions are no longer confined to the commercial codes of the magazine but, rather, have social, psychological, and cultural implications beyond the hermetic world of fashion.

cinematic takes

Pages 34–41

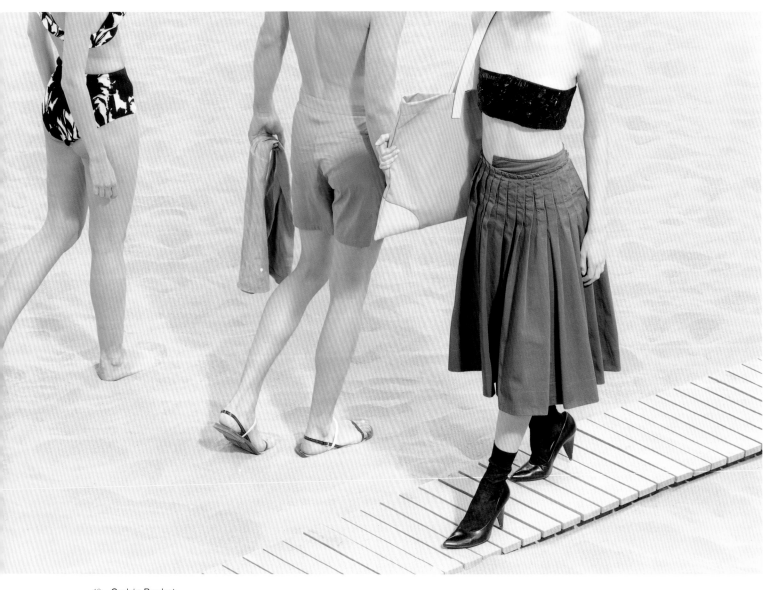

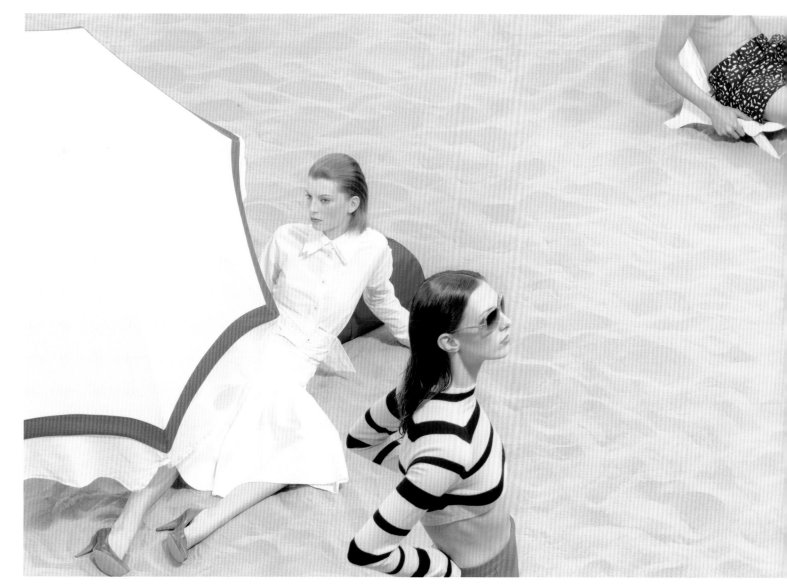

CUBA

LIBRE

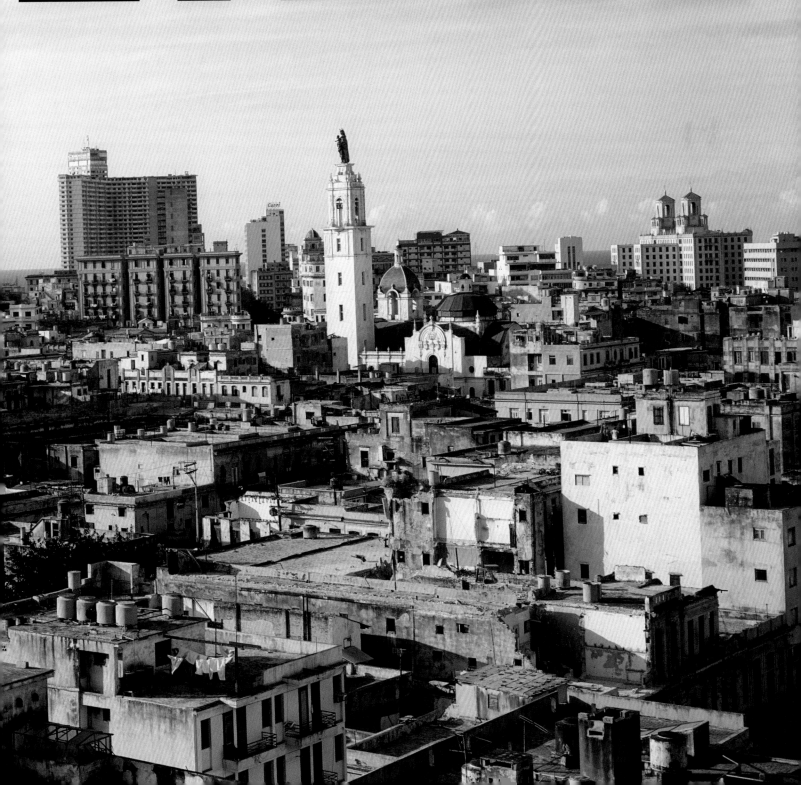

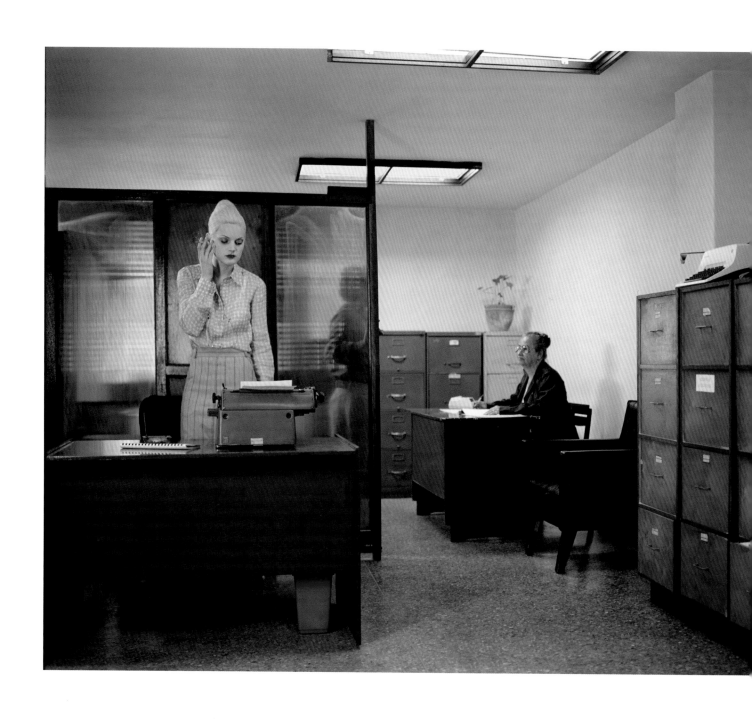

PHILIP-LORCA DICORCIA

"Cuba Libre,"

W, March 2000

Pages 42–53

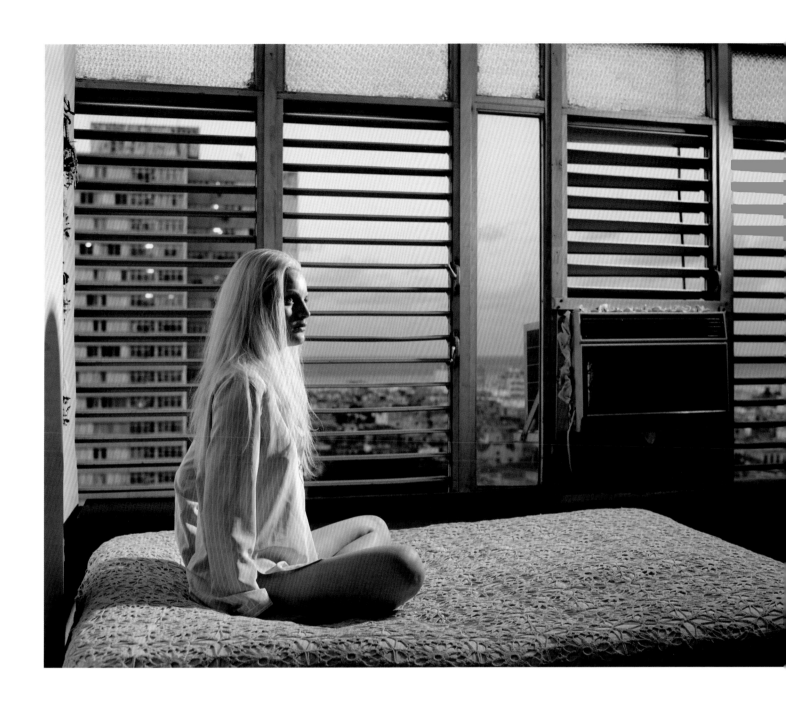

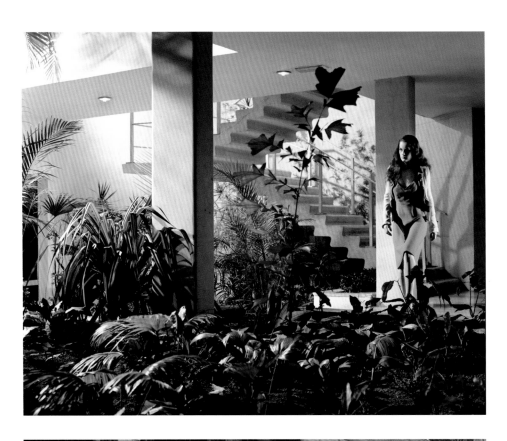

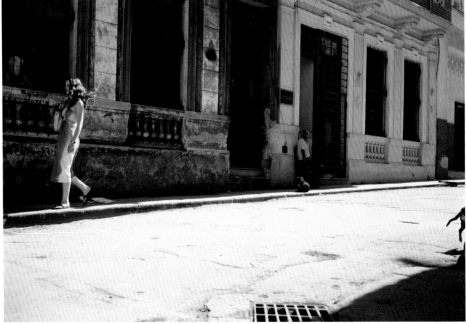

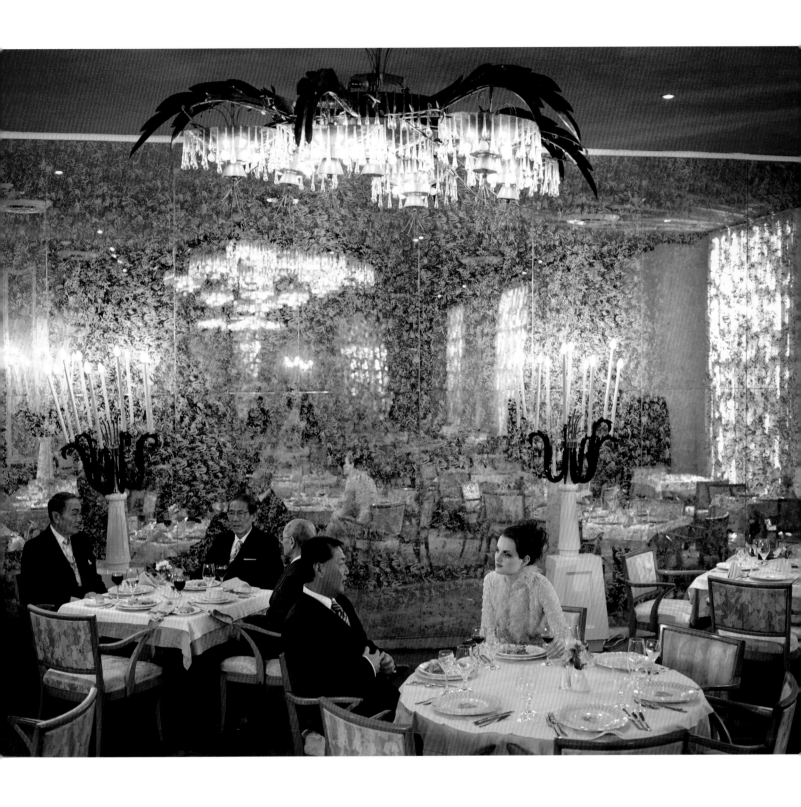

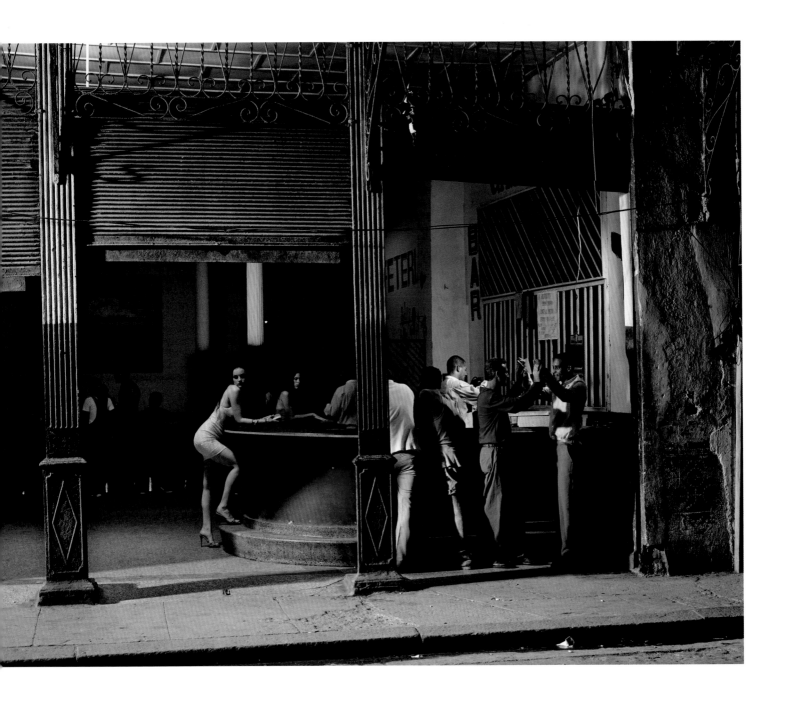

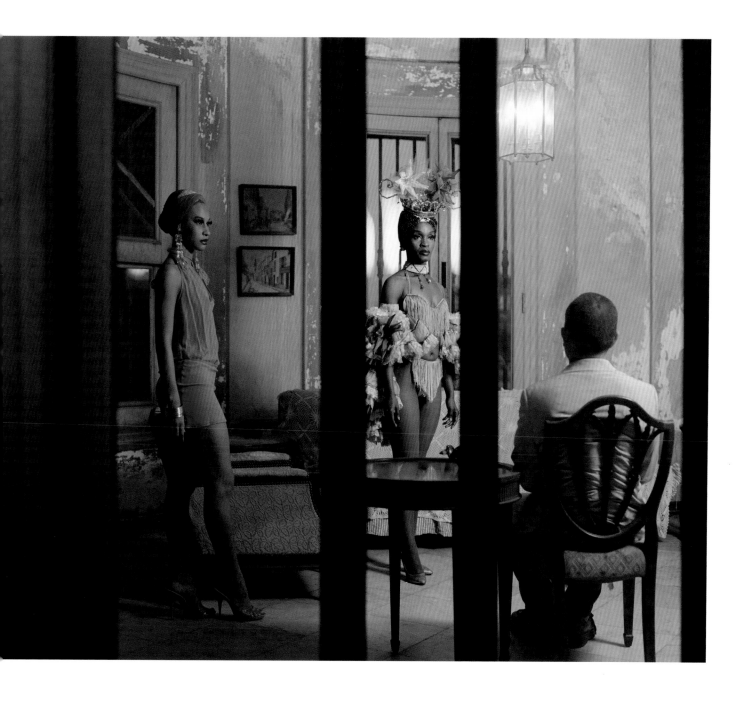

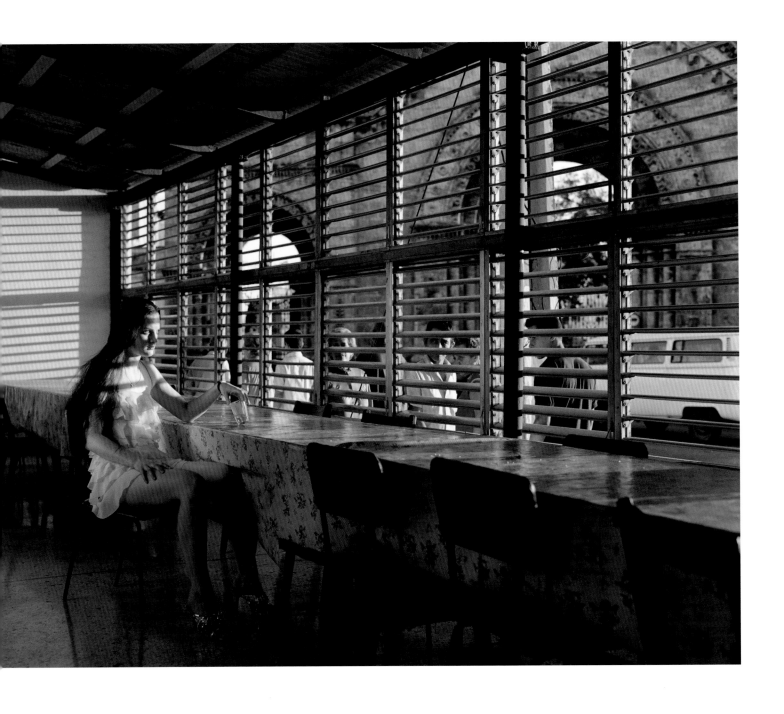

CINDY SHERMAN

"The New Cindy Sherman Collection."
Harper's Bazaar, May 1993
Pages 54, 59–61

Comme des Garçons advertising campaign
Spring/Summer 1994
Pages 55–56

Dorothée Bis advertising campaign
1984
Pages 57–58

above *Untitled #277*
opposite *Untitled #299*

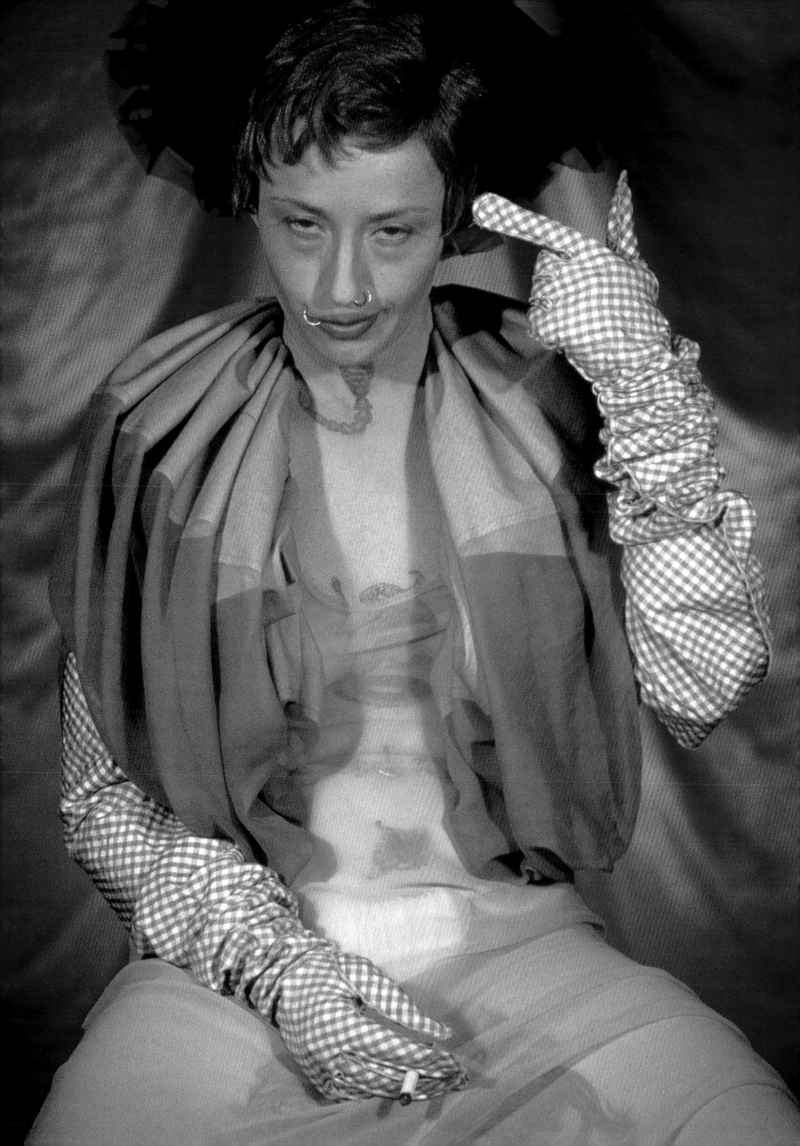

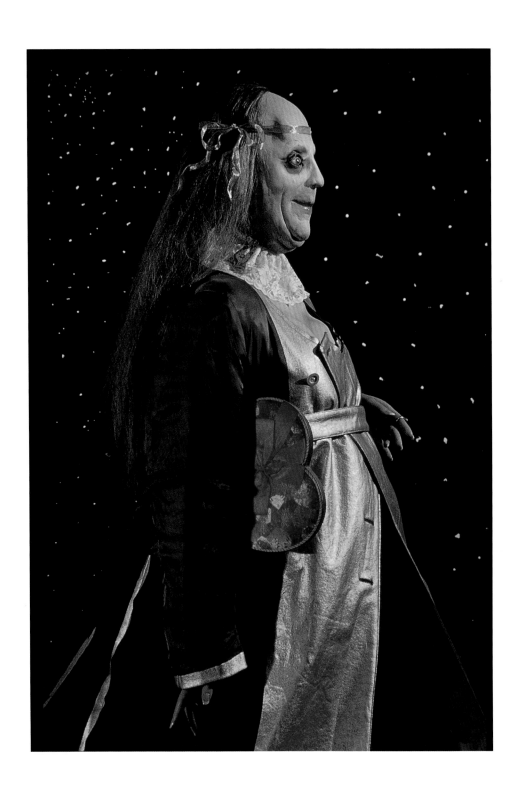

above *Untitled #297*
opposite *Untitled #133*

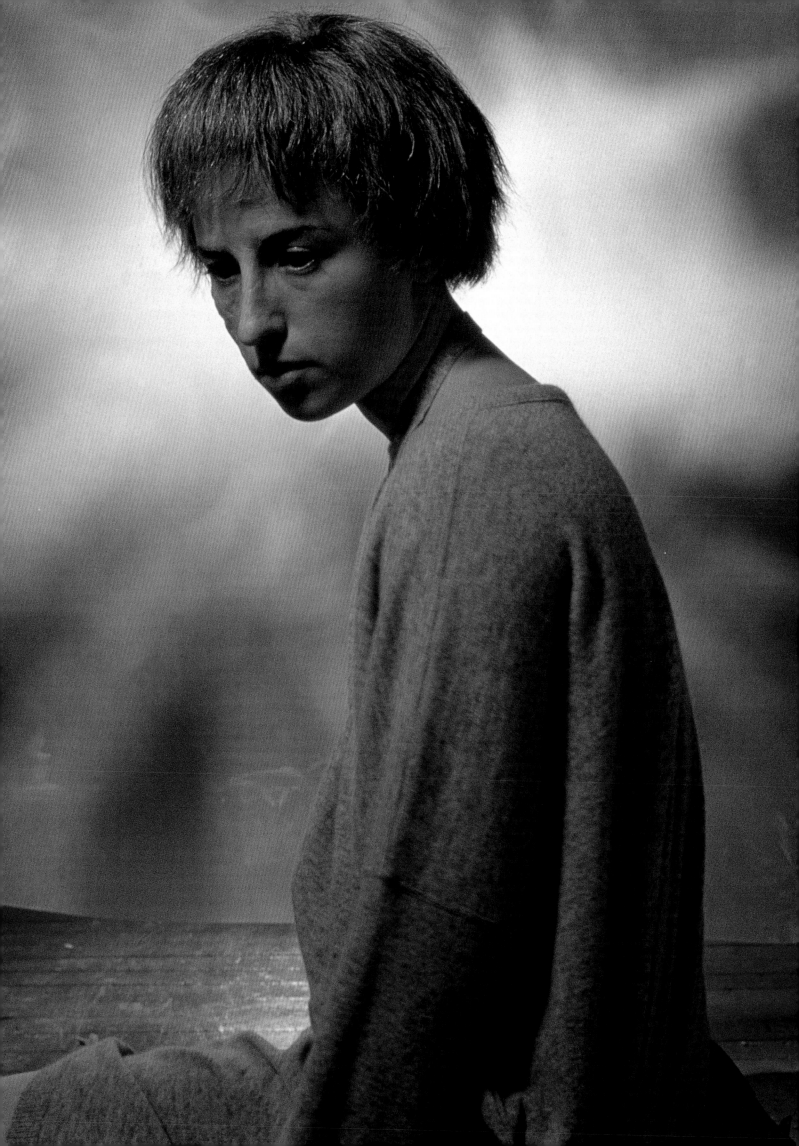

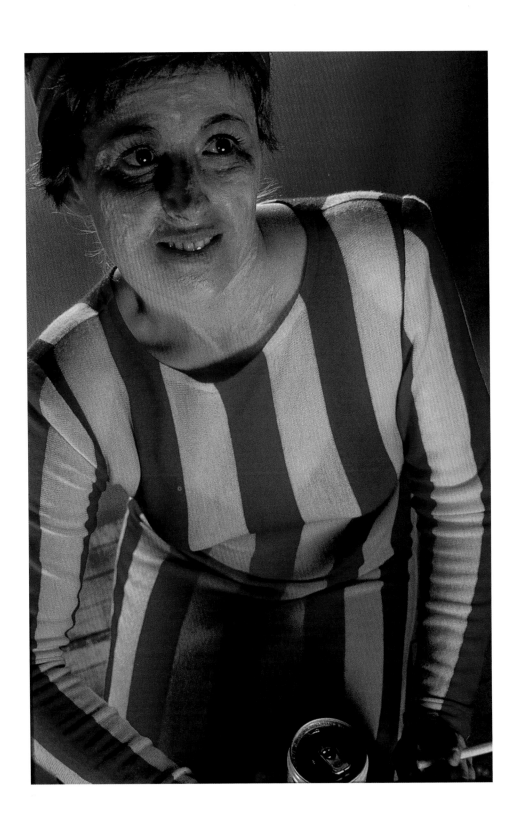

above *Untitled #132*
opposite *Untitled #279*

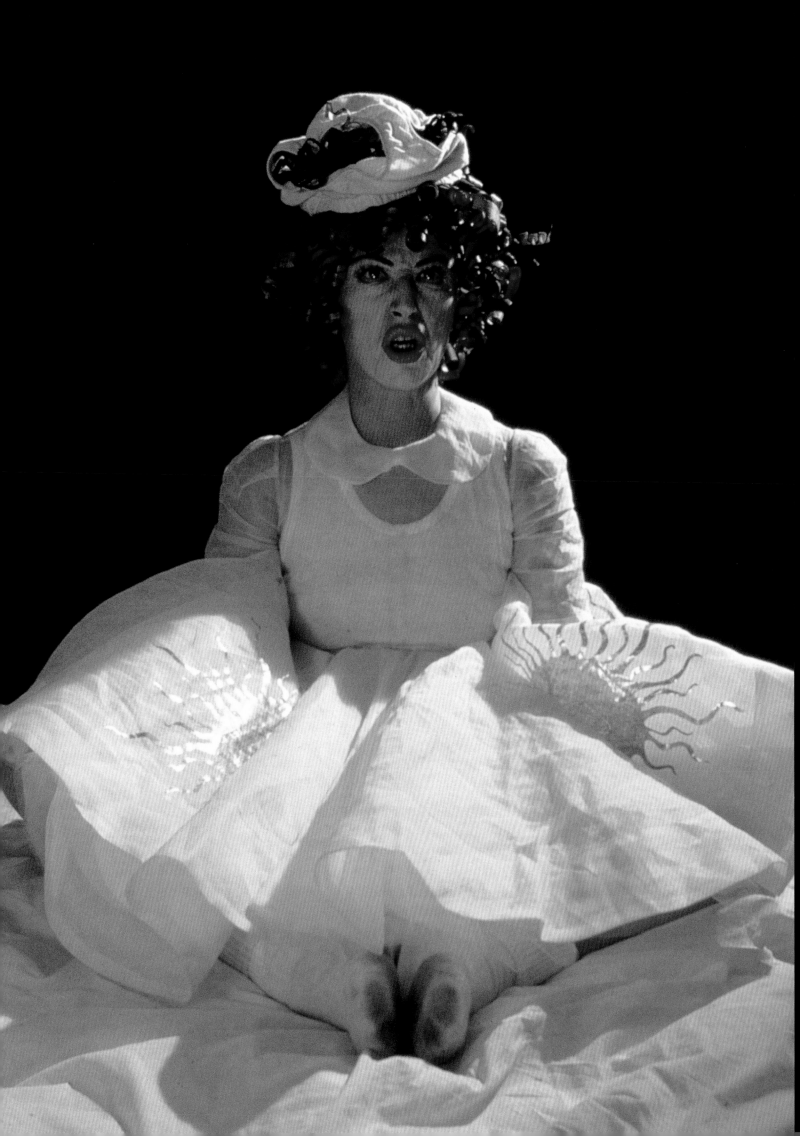

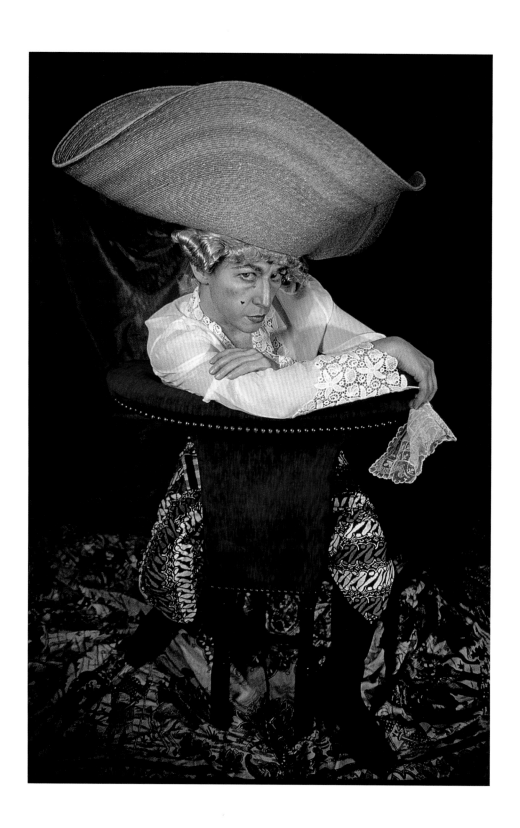

above *Untitled #281*
opposite *Untitled #278*

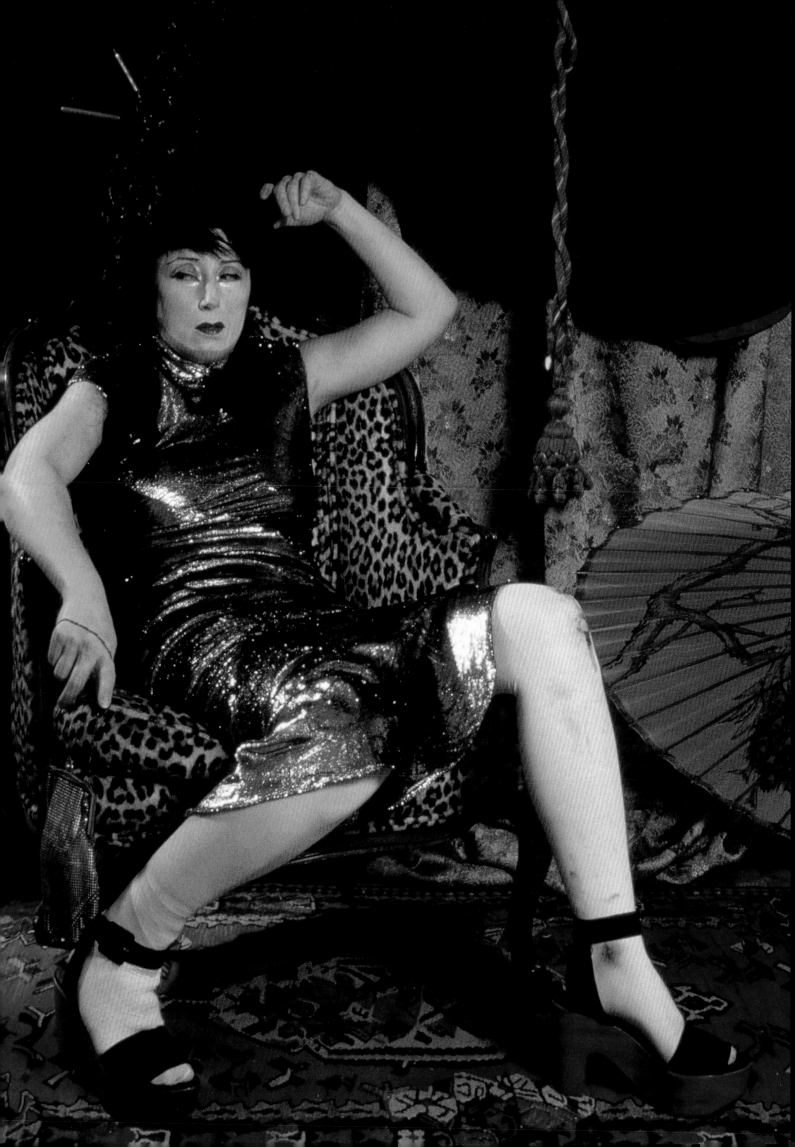

ELLEN VON UNWERTH

Alberta Ferretti advertising campaign
Fall/Winter 1995
Pages 62–67

Pages 62–67

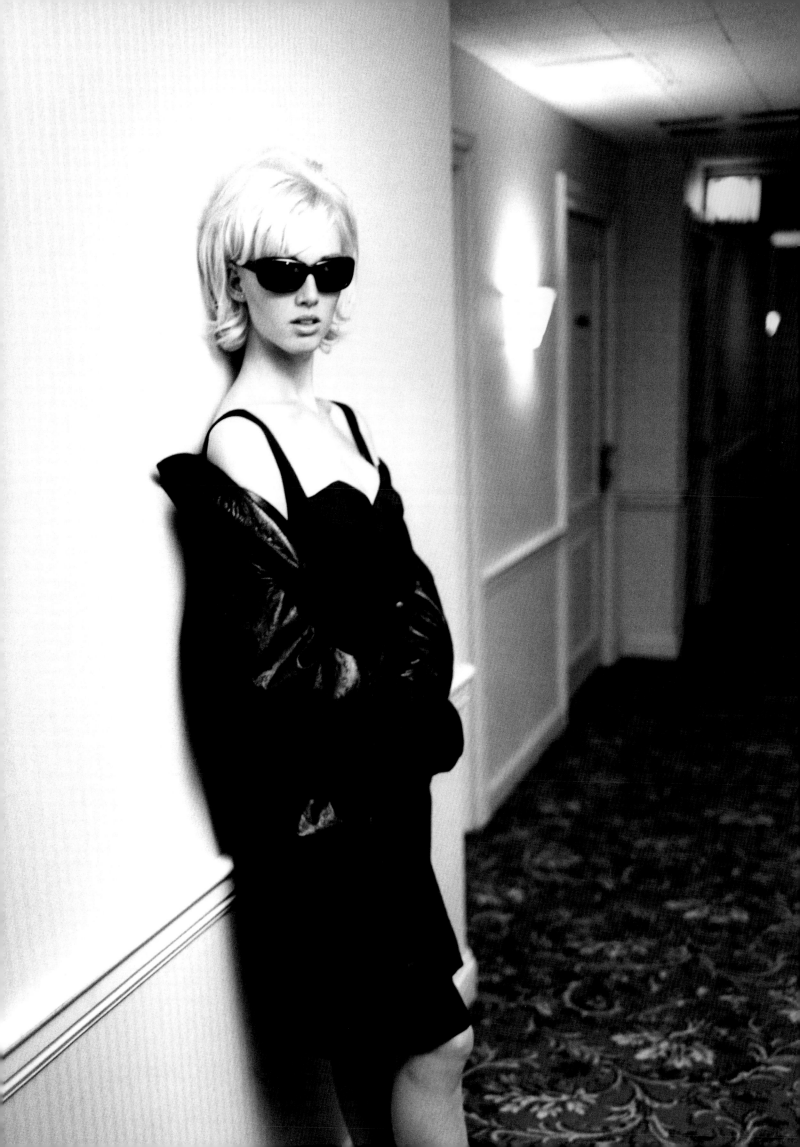

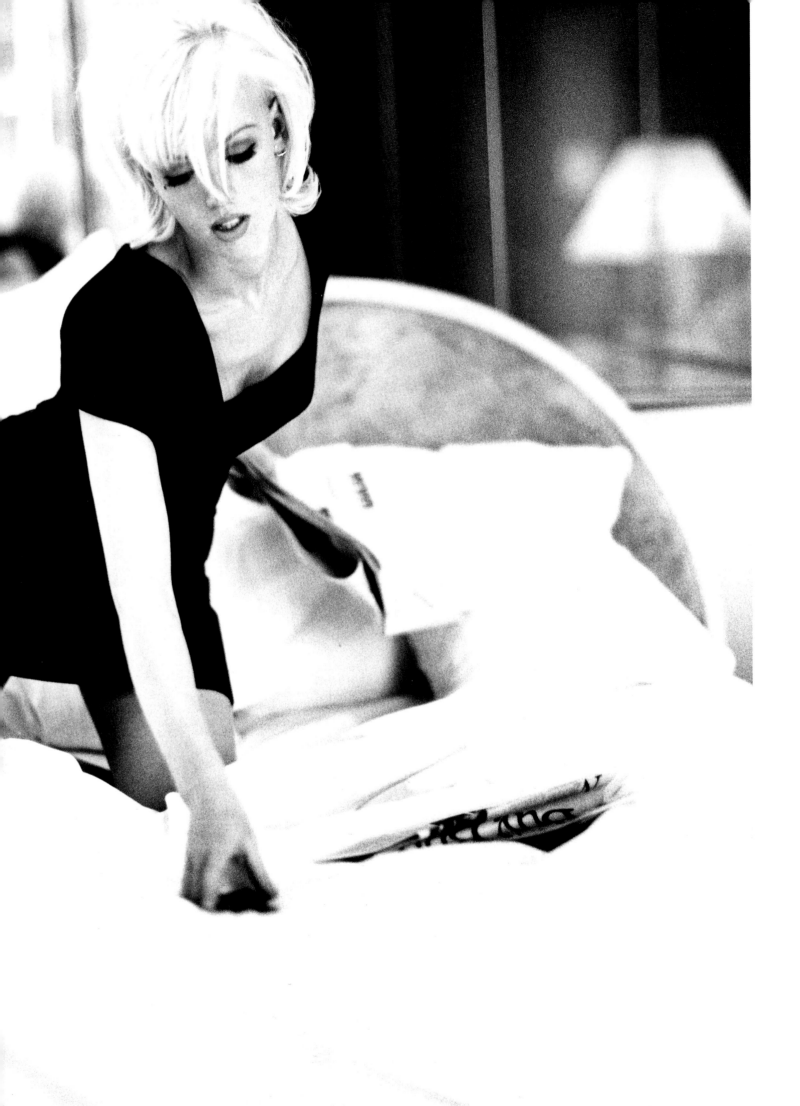

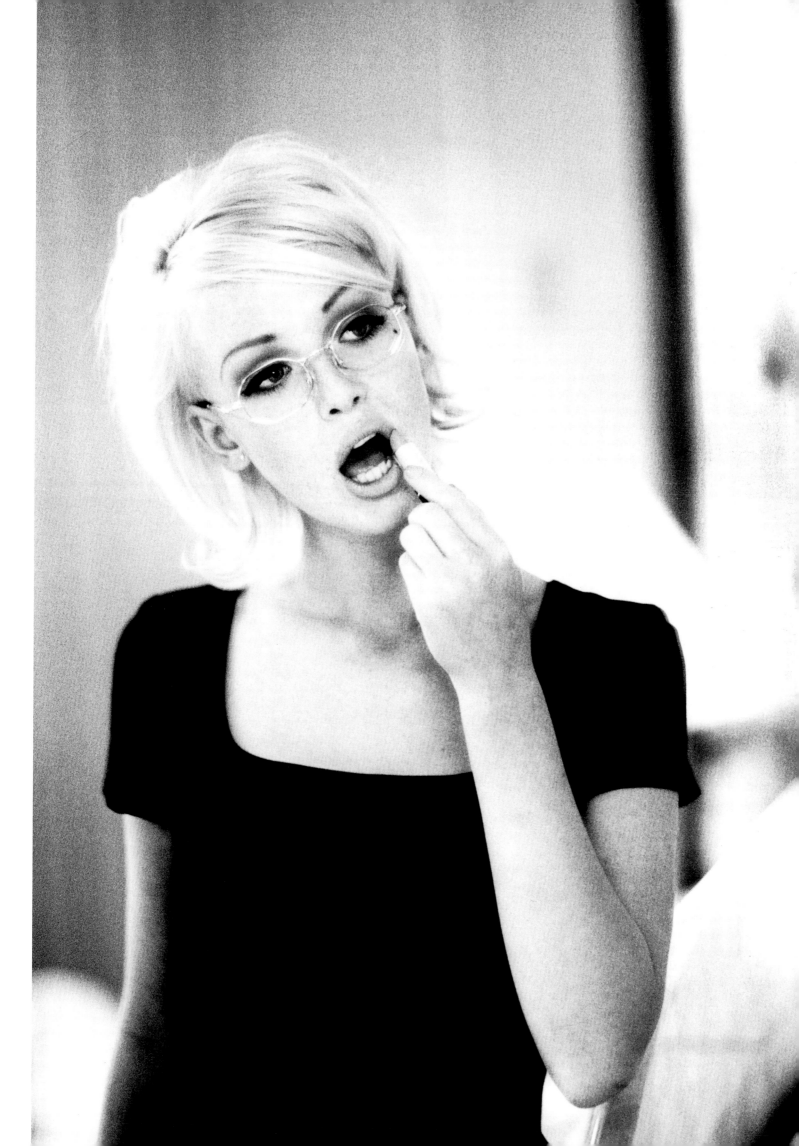

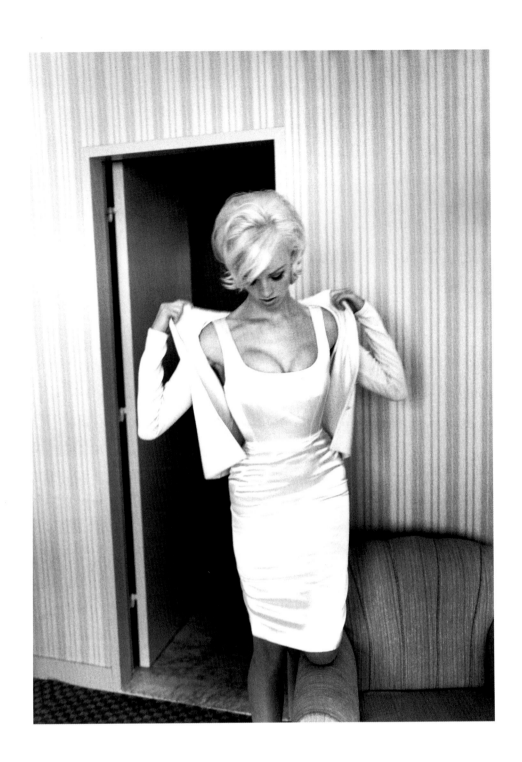

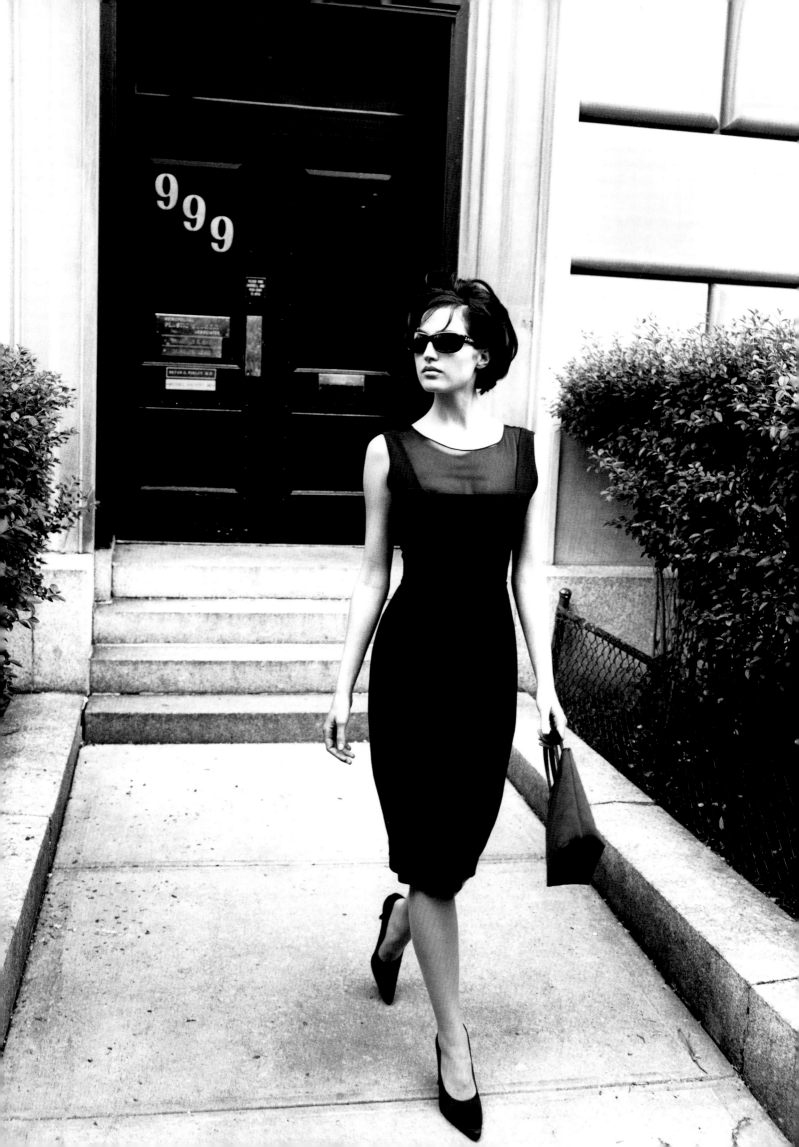

GLEN LUCHFORD
Prada advertising campaign
Fall/Winter 1997
Pages 68–69, 72–75

Prada advertising campaign
Spring/Summer 1998
Pages 70–71

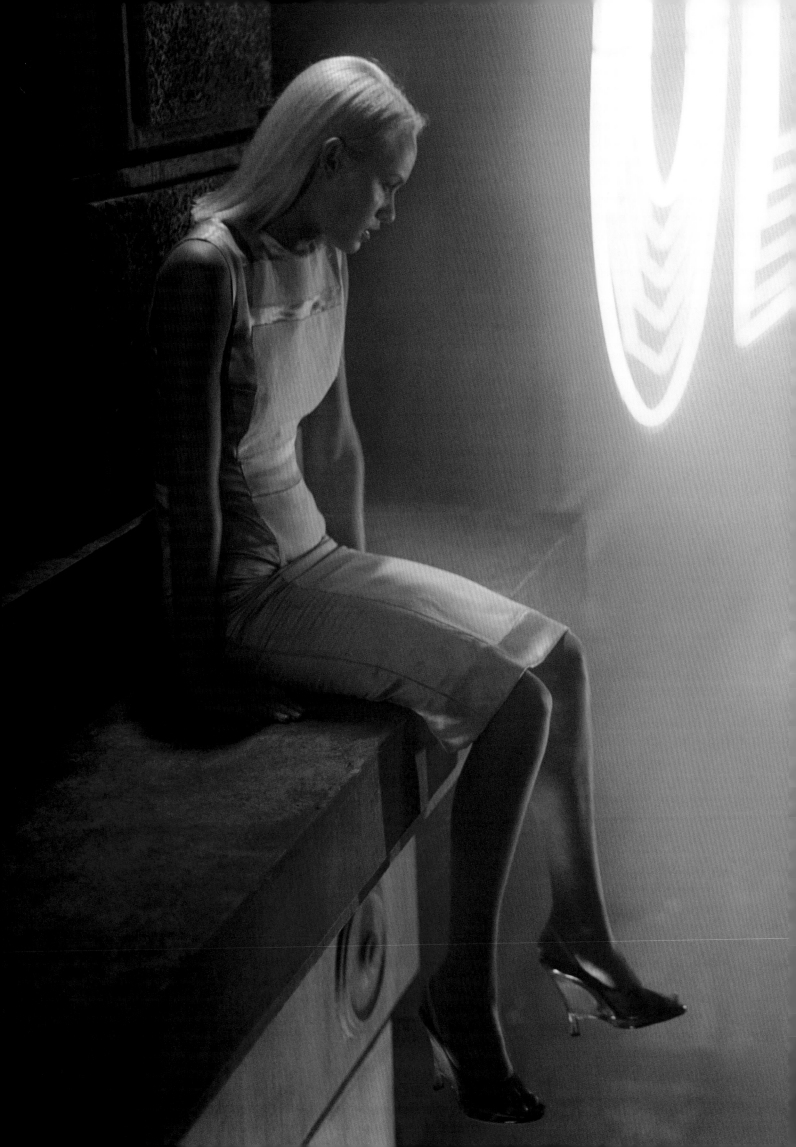

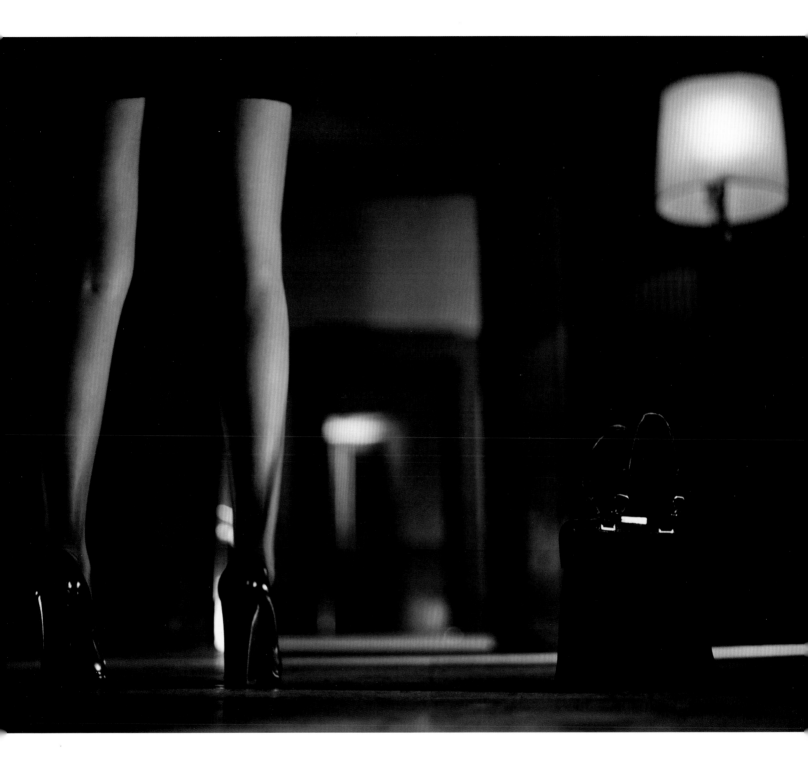

personal fictions

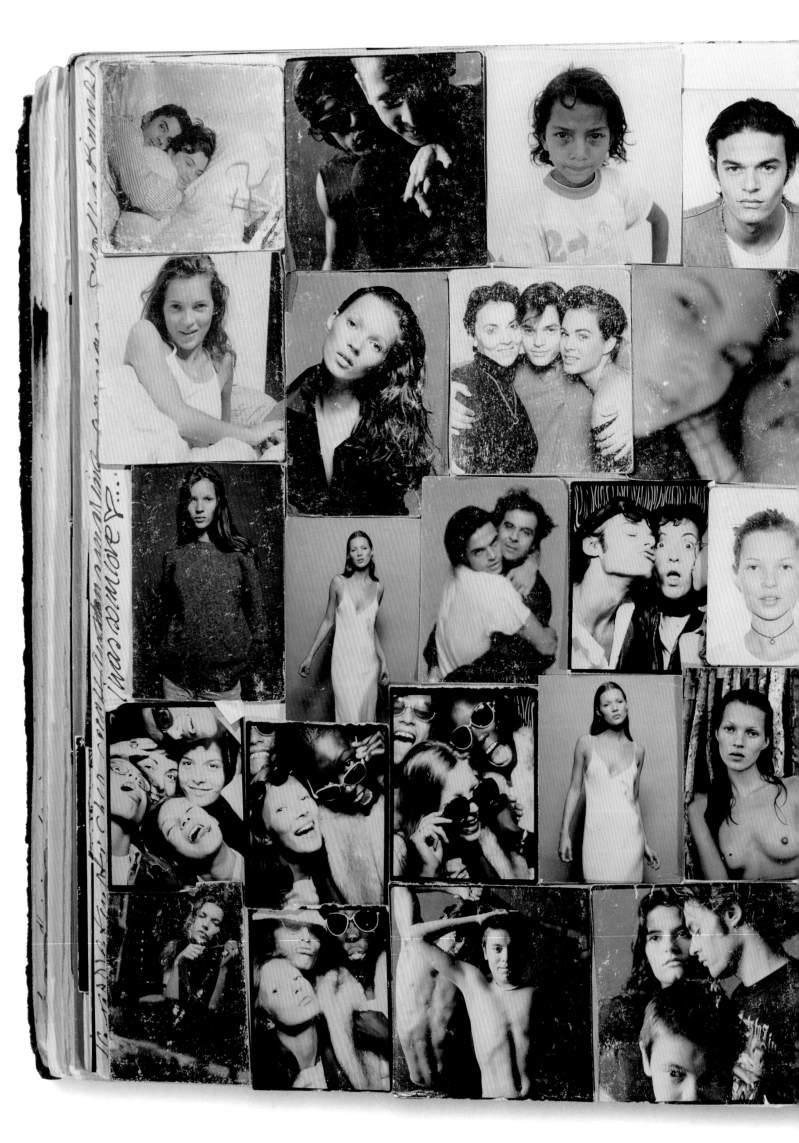

you can never be free you can never be strong. You
#-ve been having the freshest time with you
dear friend in Italy. We met in Roma
to do the Neneh Cherry job with
I went really well she's mad
cool so fresh her brother is that
dude eagle eye I meet
him on a job Before
anyway had a great
time shooting her
we went to Milan
to shoot the record
cover came out we
so drew frank and I
decide to rent a car
and drive off it
was drews Birthday
so we first
drove to
so venice
which
was such
a fat town
but first we
went
swimming
in this town
in Italy
and then we went to portovenere

the moment that I can feel my fear it

MARIO SORRENTI

Diary, 1994–95
Pages 78–79

"One,"
Another Magazine, no. 1, Autumn/Winter 2001
Pages 80–83

Diary, 1997–98
Pages 84–85

above *Untitled*
opposite *Hestone, Self-Portrait*

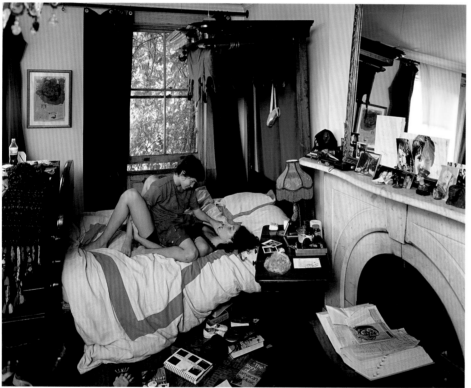

top *Lucie and Alma*
bottom *Lola and Vito*
opposite *Happy Hour*

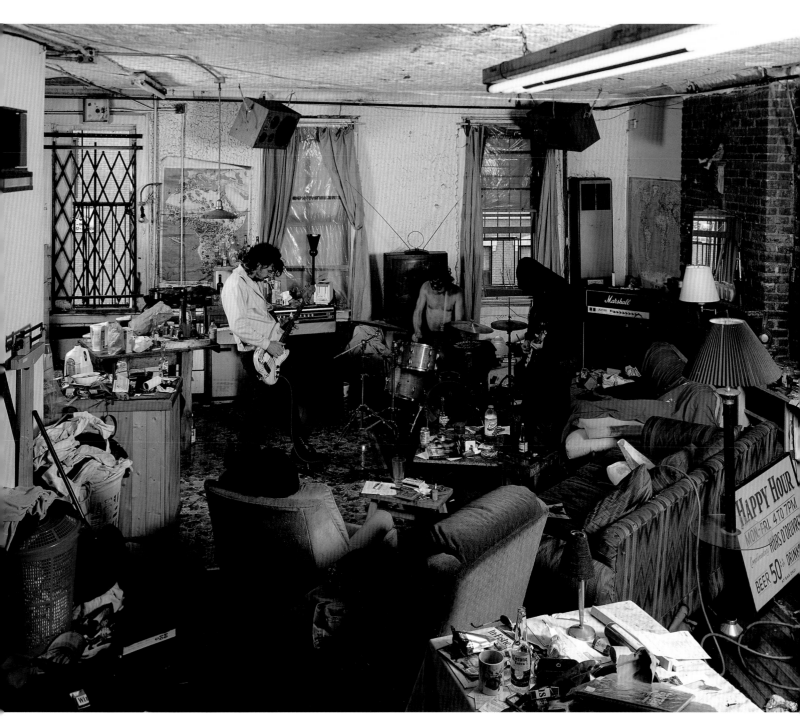

Death By Boredom,
Sentenced to
Hopelessly hung
by the telephone.
Crippled by the
repetitious echo
of the absent
lover 2.00 Am
where are my
emotions leading
me. I sigh smoke
more cigarettes and
drink more tea
and you'll be ok
lover are. my
friend damn my
self for feeling
so alone. alone
in my youth *.

"Messages for my sweet Mario
the King Of Hearts"
from his most honourable and devoted
Milla "Queen of Hearts" which goes
as follows: "From all your subjects
trying desperately to reach you,
please check them over the phone
I love you ☺"

SIDE BESIDE SEESIDE B LOVE MO

you let me down

fashonvictimartisthumanbeing
photographer filmaker representer

mark j lebon

STUDIOStheGARAGEonBAYFORDrd
62aWAKEMANrd
LONDON nw10 5dg
ENGLAND
TEL: LONDON 0181 968 8778

ever find someone
loves me as must for
them why isnt this

milla says she loves me no
she after say she told me
that i was the man that one
that i have have a
you i believe that

not realy feeling that great
milla is in cardif for the
film festival whate that
washing my clothes and

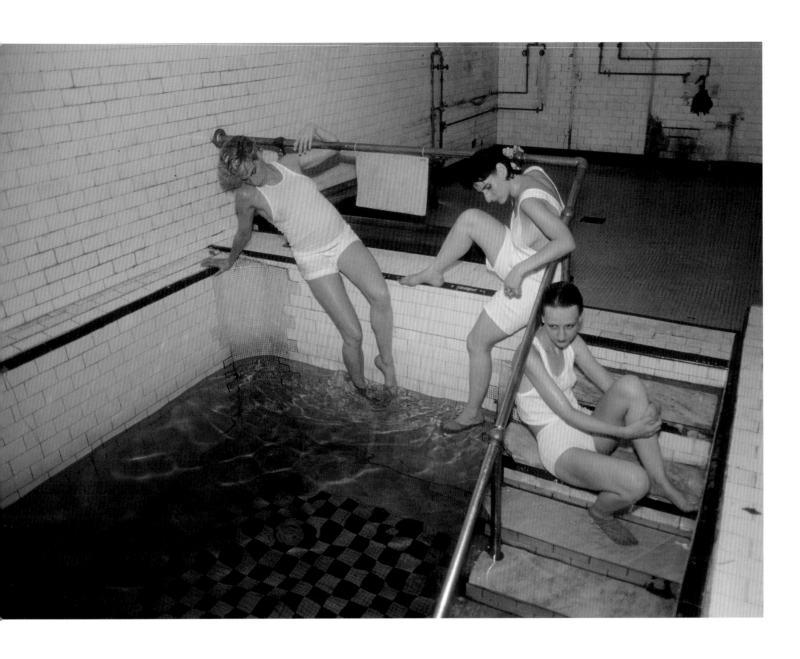

NAN GOLDIN

"Masculine/Feminine."
View, 1985
Pages 86–93

above *Three Friends at Plunge Pool, Russian Baths, New York City*
opposite *Rebecca Fastening Her Bra, Russian Baths, New York City*

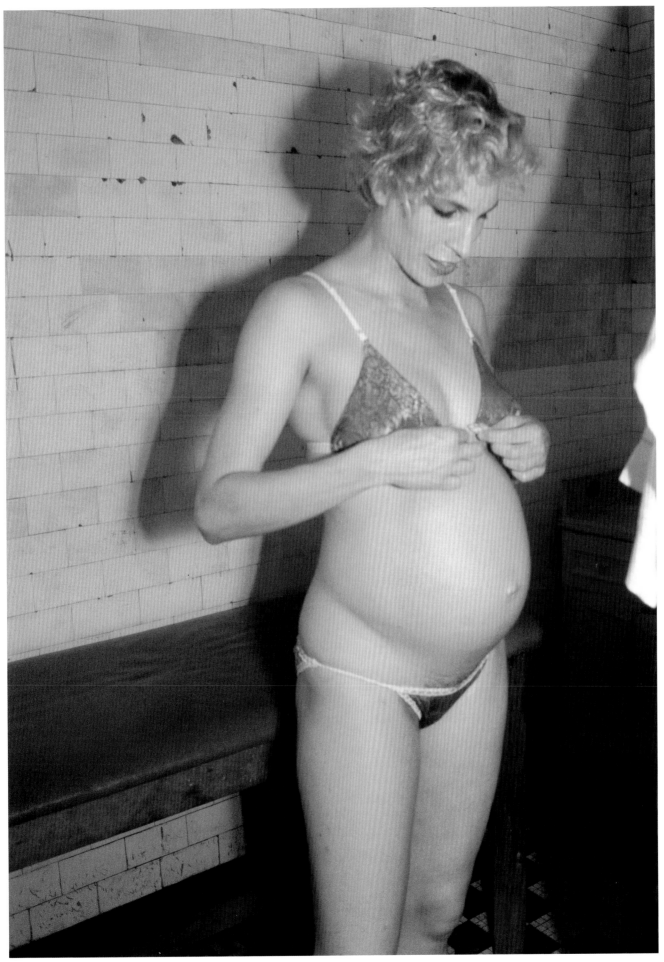

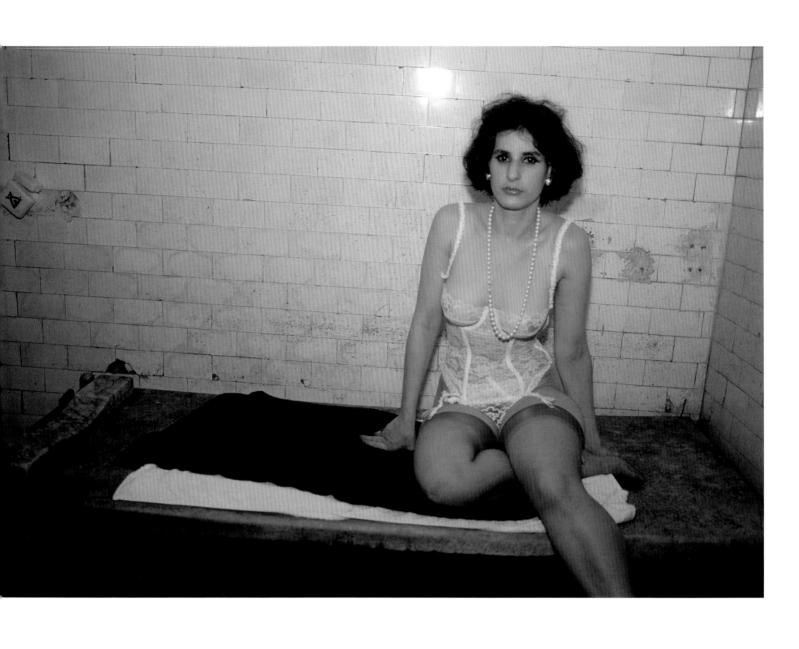

above *Untitled, Russian Baths, New York City*
opposite *C.Z. Lying in Sauna, Russian Baths, New York City*

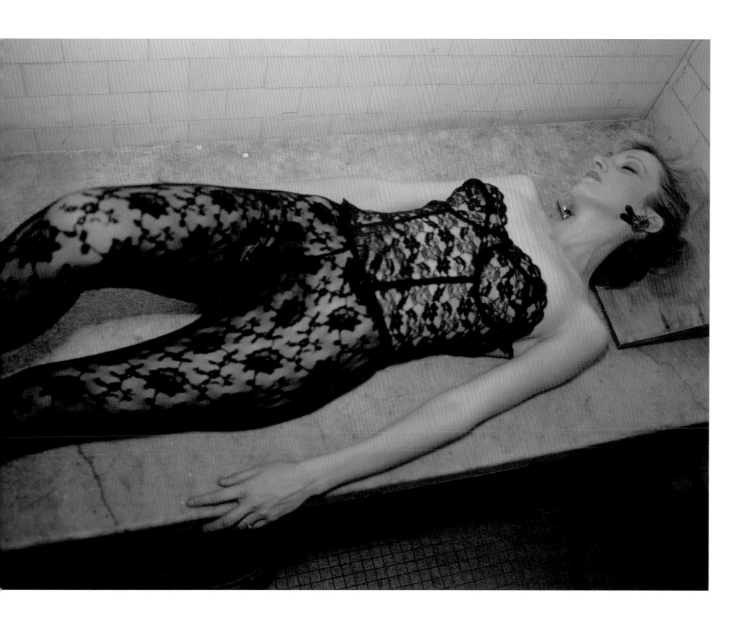

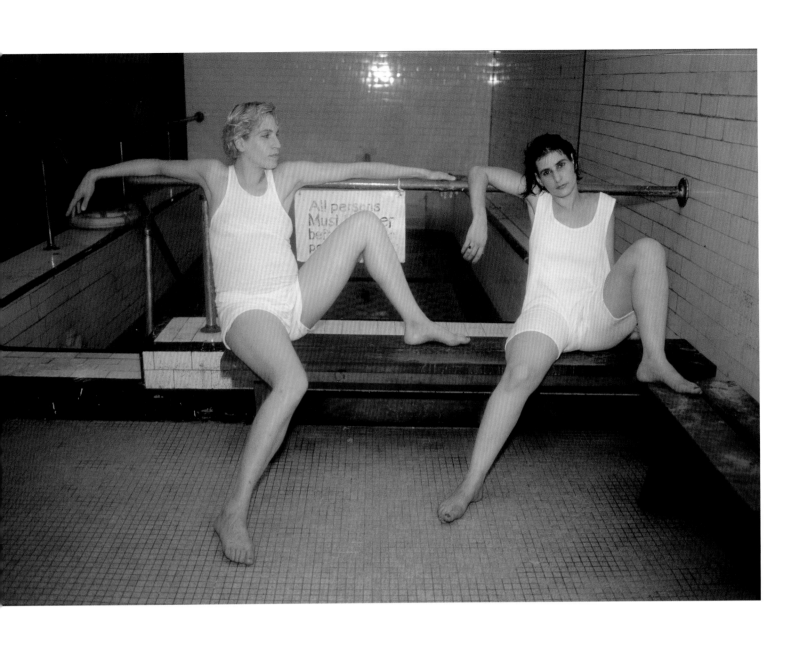

above *Two Friends in Boys' Underwear, Russian Baths, New York City*
opposite top *Three Friends on Beds after Sauna, Russian Baths, New York City*
opposite center *C.Z. on the Bed, Russian Baths, New York City*
opposite bottom *Friends Changing in Locker Room, Russian Baths, New York City*

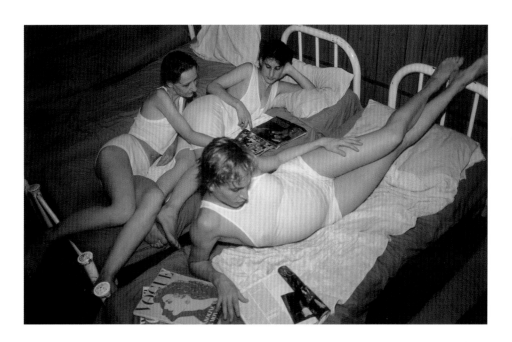

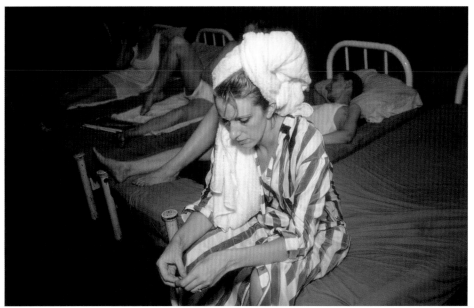

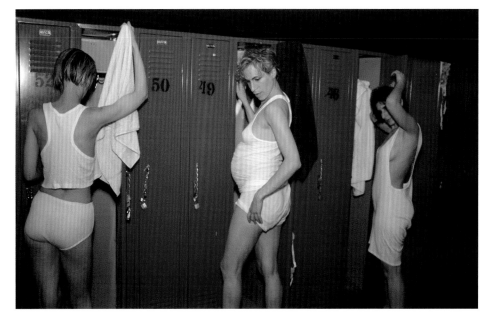

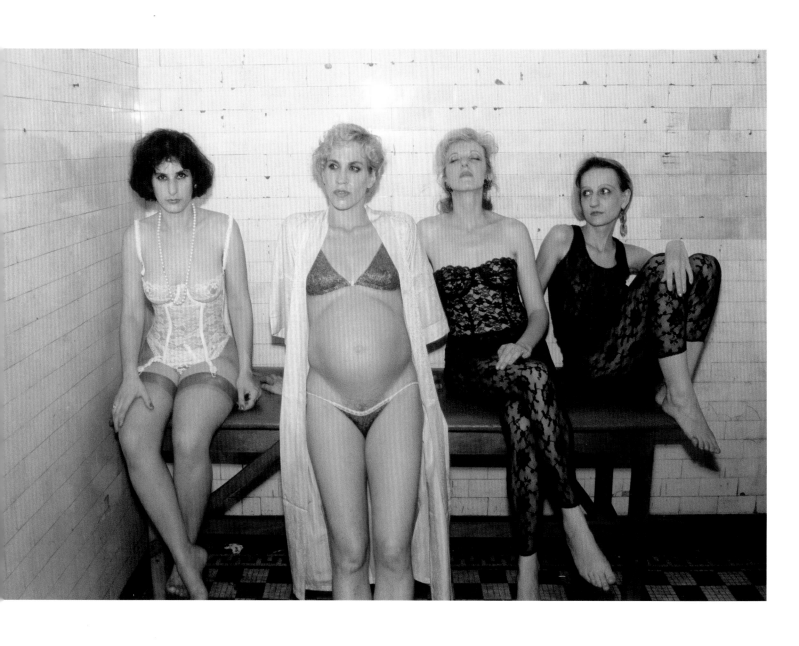

above *Four Friends in Underwear, Russian Baths, New York City*
opposite top *Untitled, Russian Baths, New York City*
opposite bottom *Suzanne on the Toilet, Russian Baths, New York City*

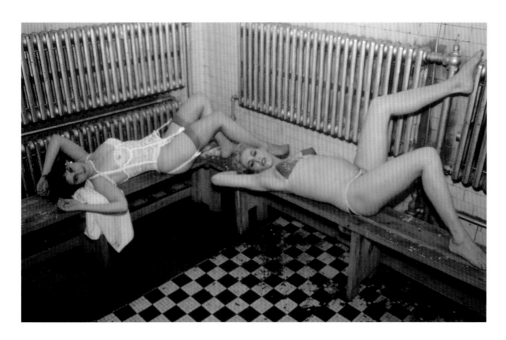

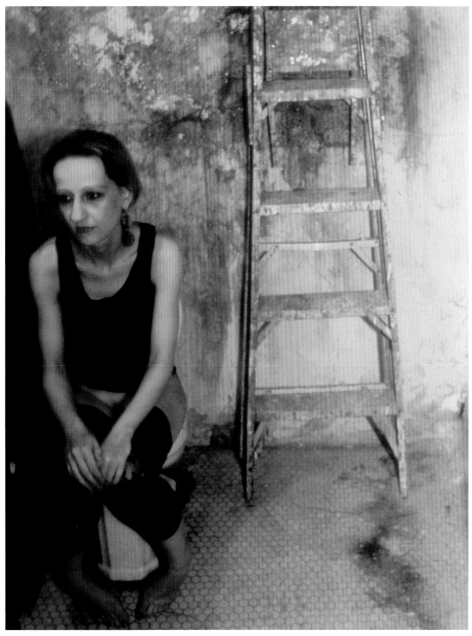

SIMON LEIGH

"Oh de Toilette"

Tank 3, no. 1, 2002

Pages 94–99

TINA BARNEY

"New York Stories,"
W, October 1999
Pages 100–105

above *Julianne Moore and Family*
opposite top *The Reunion*
opposite bottom *The Red Lipstick*

above *Joan Didion*
opposite *The Mardens*

The Pool Construction

STEVEN MEISEL

"The Good Life,"

Vogue Italia, October 1997

Pages 106–111

JUERGEN TELLER
"The Clients."
W, March 1999
Pages 112–119

above *The Clients, Haute Couture: Marie-Chantal of Greece, Paris*
opposite *The Clients, Haute Couture: France Goldman, Paris*

below *The Clients, Haute Couture: Jacqueline de Ribes, Paris*
opposite *The Clients, Haute Couture: Anne de Bourbon, Paris*

LARRY SULTAN

"Visiting Tennessee,"
Kate Spade advertising campaign
Fall/Winter 2002
Pages 120–127

interview with DENNIS FREEDMAN

by **SUSAN KISMARIC** and **EVA RESPINI**

As the Creative Director of W *magazine and Vice Chairman of Fairchild Publications, Dennis Freedman occupies an important position in fashion photography. His more than twenty years of experience and his substantial creative impact in the field illuminates the aspects of fashion photography described in this volume and in the exhibition it accompanies. Over a period of several weeks, Freedman and the exhibition's curators engaged in a dialogue on the subject, in which he shared his thoughts on innovations in recent fashion photography, past practices in the genre, the interests and experiences that led up to and informed his career, as well as how the process of making a fashion photograph actually works. In detailed examples, he explains just what the stylists, art directors, models, editors, photographers, creative directors, and their associates actually do to make the cutting-edge editorials we see in magazines.*

Q: To begin with, where and what did you study?

A: I studied art at Pennsylvania State University, a school known in the mid-1970s for its football team and its agricultural-science curriculum. Strangely enough, that juxtaposition worked for me. Within shooting distance of Beaver Stadium was the campus slaughterhouse, the subject of my first Super-8mm film. Nothing could have been more alien to my conventional middle-class Jewish upbringing. I also spent time in the library looking at foreign design magazines such as *Abitare* and *Domus*. I was fascinated by contemporary European architecture and radical Italian furniture of the 1970s.

Q: Did you study photography?

A: I completed one introductory photography course. The only thing I remember is a pair of cardboard stand-up dolls I constructed as a self-portrait. They were made from black-and-white photographs of my roommate's girlfriend in her bra and panties and myself in Hanes jockey shorts, athletic socks, and wire-rimmed glasses. All of the detachable clothing and accessories were created out of snapshots of our generic college wardrobes. I like to think that there is a connection between those paper dolls and my later work as creative director of *W* magazine. At any rate, they are the only fashion photographs I have ever taken.

Q: Did you continue at an art school?

A: Penn State had an overseas study program with the Slade School of Fine Art in London. Unfortunately my application was rejected. However, I was determined to go to England, so I found a small liberal arts school called Beaver College, which had a similar arrangement with the City of London Polytechnic. It was a transitional step for me, having spent four years on a relatively isolated college campus. For the first time in my life, I was exposed to the rich cultural diversity of a great city. At every turn I discovered something new, whether it was a building by Edwin Lutyens, a terrace by John Nash, or a church by Nicholas Hawksmoor. Like any first-time student abroad, I experienced American culture from the outside rather than the other way around.

Q: What did you do after London?

A: I enrolled in the program for interior and urban design at the Parsons School of Design in New York. I was interested in architecture, but didn't feel that I had the necessary skills to pursue it as a profession; Parsons was a kind of compromise. The waning years of the 1970s were a heady, tumultuous time, and I was eager to take it all in. While at Parsons, I discovered The Museum of Modern Art's 1966 book by Robert Venturi: *Complexity and Contradiction in Architecture*. It had an enormous impact on me; Venturi championed work that was "inconsistent and equivocal rather than direct and clear," and advocated "messy vitality over obvious unity" and "richness of meaning rather than clarity of meaning." As a student caught in the Minimalist aesthetic of the period, I found Venturi's theories liberating and as relevant to art and photography as they were to architecture.

Q: How did you get from Parsons to the magazine world?

A: After I graduated from Parsons, I spent three frustrating years as an interior designer. So with the encouragement of one angry, litigious client, I closed up shop. I had always been interested in typography but had never studied graphic design. Serendipitously, my best friend turned out to be the dentist of the art director Charles Churchward. At the time, he and Ruth Ansel were redesigning *House and Garden* magazine. I got an appointment to see Charles, and he recommended my taking courses at the School of Visual Arts. Before I left, he introduced me to Ruth. To put this in historical perspective, it was in 1963 that Ruth Ansel and Bea Feitler succeeded art director Marvin Israel at *Harper's Bazaar*. They were both then in their early twenties, and the youngest creative art-director team in the history of the magazine. It was a field dominated by men. Their predecessors were Israel, Henry Wolf, and Alexey Brodovitch. For nine years, Ruth and Bea forged a revolutionary new direction for the magazine, mixing conceptual photography with Pop art, street fashion, rock music, and film. The new talent that they brought to *Bazaar* changed the face of fashion photography: Bob Richardson, Melvin Sokolsky, James Moore, Jeanloup Sieff, Frank Horvat, Bill King. These photographers joined an existing stable of greats such as Richard Avedon and Robert Frank. Ruth and Bea were the first to commission Guy Bourdin. They got Andy Warhol to design a multiple-image double-page spread. Claus Oldenburg, Roy Lichtenstein, George Segal, and Robert Rauschenberg all contributed to their art-inspired Pop issue. And it was these two women who helped support the financially struggling young photographer Diane Arbus.

In Ruth's office, I was shown her mock-up of the newly redesigned *House and Garden*, and she asked me what I thought of it. I have no idea what I said. I just remember walking out of the Condé Nast building elated. With that simple gesture, Ruth had made me believe that my opinion counted. And, many years later, in an extraordinary twist of fate, on the night that Ruth was inducted into the Hall of Fame of the Society of Publication Designers I received my first Gold Medal for Photography as Creative Director of *W* magazine. Over a decade had passed since we had last seen each other at *House and Garden*.

Q: How did you get your first magazine job?

A: I took Charles Churchward's advice and enrolled in two evening courses at the School of Visual Arts. One was devoted to making a prototype magazine. The really wonderful thing about creating an imaginary magazine is that you are allowed to steal any photograph, illustration, or painting you want from books, catalogues, or periodicals. All you have to do is cut out an image and paste it down; I could appropriate work by Garry Winogrand, Lee Friedlander, Robert Frank, Ellsworth Kelly, Lucian Freud—anyone I admired. Regrettably, I cut up my first-edition copy of *William Eggleston's Guide,* published in 1976 by The Museum of Modern Art, which later came to be one of the landmark photography books of our time.

Recently, I found my original prototype magazine of twenty years ago. One of the paintings I used was a Chuck Close portrait of the composer Philip Glass. Ironically, I had had no recollection of that when I asked the artist to make a series of daguerreotypes of the model Kate Moss for *W* magazine that were published in September 2003 (fig. 1).

With work by Eggleston and Close in my portfolio, it is not surprising that I got a job. At the time, Fairchild Publications was launching a new men's magazine called *M* and they needed a freelance designer. The art director, Owen Hartley, took a chance and hired me.

Q: How did you go from being an assistant art director at a men's magazine to the creative director of *W*?

A: It was the idea of John Fairchild, the chairman and editorial director. He noticed early on that I had a fairly wide range of interests. He often invited me to lunch, but we rarely talked about work. Our conversations concerned day-to-day events—movies, plays, museum exhibitions—anything but fashion. In those days, I was spending a lot of time in London. I would often come back with ideas for stories. Then one afternoon in 1989, out of the blue, Mr. Fairchild called me over to his desk and offered me the job of features editor of *W*. I was the art director of *M* magazine and had never edited anything in my life. When I explained this to him, he simply asked if I could recognize a good story. I said I could. He said that was all that mattered, and I became the features editor of *W*—just like that. Of course I was terrified. I can't imagine what went through the minds of the writers. Looking back, I'm sure Mr. Fairchild believed that if he brought me over to *W* things would change. My job was to stir up the pot.

Q: How did you make the transition from features editor to creative director?

A: First of all, you have to understand what *W* was at that time. Put simply, it was a broadsheet created by Mr. Fairchild that chronicled the worlds of fashion, society, travel, and culture with irreverence, wit, and devastating honesty. With *W* as his weapon, Mr. Fairchild lampooned anything or anyone pretentious or self-important. He invented the *In* and *Out* lists. *W* was the first to make celebrities out of fashion designers by documenting how they lived, worked, and thought. It was the beginning of a whole new genre of magazine. Like its creator, *W* was an original—opinionated, controversial, mercurial, and bigger than life. But one thing that didn't measure up was the photography. Staff photographers did all assignments, and, for the most part, the designers themselves booked cover models. Because of the unorthodox nature of the publication it all seemed to work; it was fresh, fast, and unpretentious. However, as the new features editor, I decided that the best way I could make a difference was to improve the quality of the photography. The extraordinary thing about the culture at Fairchild was that I was able to do that. No one asked any questions. I never had to edit a story. There were no deadlines. I was given a desk and a telephone—and total freedom.

So I spent the first few months educating myself about the complex workings of the fashion industry. I learned that the process of putting together a major consumer fashion magazine depended on an interdependent web of relationships in which everything centered on the photographer. His or her status determined the choice—or level—of the model, the hairstylist, and the makeup artist. Without the right photographer there is very little chance of assembling a talented team of collaborators. One of the reasons for this is that the model, hairstylist, and makeup artist are paid nominal fees to work for fashion magazines. For example, a top model, who

can make two hundred fifty thousand dollars or more a day to do an advertising job, is paid a fee of two hundred and seventy-five dollars to do an editorial. She will work for a magazine only if it improves her portfolio and advances her career. It gets more complicated when you consider the fact that many photographers have exclusive contracts with major publishing houses. As I quickly learned, *W* wasn't even on the radar screen.

Q: Given those circumstances, what did you do?
A: I used my imagination. I created a story called "The People Who Make New York, New York." Of course, the cover would have to feature the most important model in the fashion industry. The whole idea was, in large part, a ploy to get Cindy Crawford, who under any other circumstances would have been unavailable. There was only one problem: we didn't have a photographer. So I called her agency and asked for a list of the people that Cindy would agree to work with. Most of the names were out of the question. They either had exclusive contracts or were unwilling to work for us. Fortunately, there was one young photographer named Antoine Verglas, who accepted. And for the first time, *W*, without the help of a fashion designer, booked a supermodel for its cover.

Q: Was that a turning point for the magazine?
A: Not really; the turning point happened much later. One day in 1992, without warning, the editorial staff was notified that in a few months *W* would be relaunched as a perfect-bound consumer fashion magazine. That meant we would be competing head-to-head with the two giants of the industry, *Vogue* and *Harper's Bazaar*. It was a monumental challenge. At the same time, *Harper's Bazaar* was being revamped by Liz Tilberis and Fabien Baron. Needless to say, they formed a brilliant and experienced editorial team armed with a substantial budget, and had one of the venerated names in the history of fashion publishing as well as the backing of the Hearst Corporation. *Vogue* and *Harper's Bazaar* were at the center of media attention; *W* was little more than an afterthought.

Q: How did you compete?
A: By the seat of our pants! I don't mean that in a derogatory way, rather, just the opposite. It was our greatest strength. There were no rules or roadmaps. I was never given a budget. I just knew there wasn't much money to spend. I didn't have an assistant; I was bookings editor, travel agent, location scout, budget manager, and creative director. I hired the models, bought the plane tickets, booked the hotel rooms, rented the cars, and assigned the photography. It wasn't until later that I was allowed to hire a college intern, Cary Leitzes, who was an English literature major at New York University. She helped me during the day and went to school at night. Cary is now the director of photography for *Harper's Bazaar*.

Most importantly, I had the great fortune to work with an extraordinary editor-in-chief, Patrick McCarthy, who has the self-confidence and intelligence to allow his creative director to do what he does best—establish the creative direction of the magazine, something almost unheard of in our industry. We both work by instinct; our meetings rarely last more than five minutes. We can take risks because the wonderful thing about a magazine is that it has a very

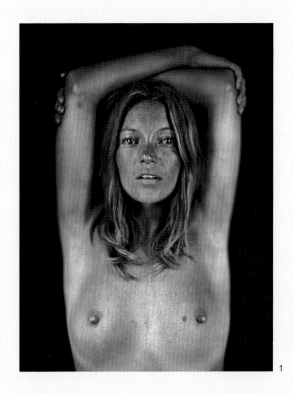

1

1. CHUCK CLOSE. "Kate Moss Portfolio," *W*, September 2003

short shelf life. It is only on the newsstand for a few weeks before another one comes along to take its place.

Q: Who else was on your creative team?

A: I have always worked with one design director, Edward Leida, and one art director, Kirby Rodriguez. Edward does the overall formatting of the magazine, and its execution is the day-to-day responsibility of Kirby and his team. Most of our creative meetings were first held in Edward's Honda Prelude, driving back and forth on the Long Island Expressway. In the end, he proposed using simple, bold typography, consistent with the straightforward character of the magazine: no pyrotechnics, no bells and whistles. The design defers to the photography. Its strength depends on the subtle balance of scale and proportion. Also on the staff at the time was a very young, inexperienced, but extremely talented fashion editor named Michel Botbol. In truth, we were all inexperienced.

Q: What was your game plan?

A: Although I never consciously developed a plan, the nucleus of one was circulating in my brain. It had been evolving over the years. Looking back, the making of those cardboard dolls in college photography class was an attempt, however sophomoric, to get at the truth—to distinguish between stereotype and reality. So here I was, twenty years later, a bit more mature, a bit more water under the bridge, placed by an improbable sequence of events, in the role of creative director of a major women's fashion magazine. It was an odd fit, since I had been inspired by the work of people like Stephen Shore, William Eggleston, Larry Sultan, and Joel Sternfeld—photographers who recorded the commonplace events of life, subjects then anathema to the fashion world. So-called beautiful pictures of beautiful women wearing beautiful clothes felt empty to me: meaningless and false. Suddenly I had crash-landed in a world based on illusion. Of course, things are never as they appear. It relates to something Diane Arbus once said: "There's a point between what you want people to know about you and what you can't help people knowing about you... the gap between intention and effect.... What you intend never comes out like you intend it." What I saw around me was troubling. At all the fashion shows, young teenage girls walked up and down the runway acting arrogant, detached, and comically melodramatic. It would have been silly if it hadn't been so sad. Then, these same girls would show up months later, wearing the same clothes, albeit with different hair and makeup, in all the major magazines, acting even more peculiar. This time, they're jumping in the air, laughing hysterically, and hop-skipping across the street—all for no apparent reason—as if they suffer from some form of bipolar disorder. The ultimate irony is that these cardboard images, these Barbie dolls, reflect nothing of the talented, intelligent, witty, and creative people who produce them.

Q: Why do you think this is so?

A: Well, I've thought about it a lot and come to the conclusion that it has mostly to do with the low level of importance attached to fashion photography. I believe that editors, for the most part, place far more value on the content of the text than on the content of the photographs. You see, most editors-in-chief come from fashion or journalism backgrounds. Their area of expertise is rarely photography. And yet in most cases they assume creative control. They edit the pictures, choose the photographers, and determine the creative direction of the magazine. It is not unlike asking an art director to edit copy, hire the writers, and decide on editorial content. It would never happen. It is very demoralizing to see photography reduced to a sales tool. Many fashion photographs are not much more than big-budget catalogue pictures—high production value substituting for content. Everything is pleasant, amusing, nonconfrontational: polite conversation, visual elevator music. Since women have been conditioned for so long to have such low expectations of fashion photographs, they don't even question the emptiness of it all. Not long ago, Ruth Ansel sent me a copy of a text written by Marvin Israel about the 1965 Pop Issue of *Harper's Bazaar*: "It flowed like a piece of music. They had this concept of a fashion magazine that told everything about what was current and future in art, fashion, thinking, music. The issue was a total concept that brought together the vitality of the period.... [It] scared the people at the top at *Bazaar*. They had started to become concerned with the economics of the market place. There was no longer a place for daring and original artistic concepts."

Q: Why should anyone expect the same artistic attention in fashion magazines and advertising as we do in museums and other venues for serious photography?

A: The truth is that for a majority of people, magazines remain the most accessible venue for looking at photography. Compared to gallery and even museum audiences, magazines have far greater reach. It is sobering to hear that the artist Chuck Close received more comments for his photographs of Kate Moss that appeared in *W* magazine than for anything else he has ever done, including his major retrospective at The Museum of Modern Art. It simply comes down to numbers—more people read magazines on a regular basis than attend art exhibitions. Unfortunately, at a time when other forms of popular culture grapple with contemporary social issues, the artistic content of most major fashion magazines lags far behind. While young directors like Todd Haynes (*Far from Heaven*) knowingly parody films from the 1950s, most mainstream magazines resemble the sugar-coated originals. While contemporary television programming challenges audiences with shows like *Curb Your Enthusiasm* and *Six Feet Under*, fashion magazines continue to churn out the one-dimensional equivalents of Ward and June Cleaver. It is ironic that this narrow depiction of contemporary life persists most stubbornly in the fashion pages of women's magazines. This was not always the case: throughout the 1930s, 1940s, and 1950s, Brodovitch introduced readers to serious photographers like Man Ray, Lisette Model, Martin Munkacsi, Herbert Matter, and Erwin Blumenfeld. At Condé Nast, editorial director Alexander Liberman experimented with the artists Joseph Cornell, Robert Rauschenberg, and Jasper Johns. And in the 1960s, French *Vogue* published the groundbreaking photographs of Guy Bourdin, Helmut Newton, and Deborah Turbeville.

Q: Isn't it the fundamental purpose of fashion magazines to show clothes? What is the relationship between commerce and culture within magazines?

A: Of course, fashion magazines need to show clothes. The real issue is how you choose to do it. By definition, magazines are editorial: they have a point of view. The creative voice is defined largely by the photography. We know that it is possible to show clothes without being superficial or one-dimensional, because it has been done. Cathy Horyn, fashion critic for *The New York Times*, wrote about this subject not too long ago, and in her article she referred to "an era when art directors like the late Alexander Liberman and Alexey Brodovitch of *Harper's Bazaar* commissioned artists, largely in the belief that they were there to sell ideas rather than mere clothes."

Q: Why do you think the focus of magazines has changed?
A: There is no one answer, but I think that a large part of the explanation lies in the increasing power and influence of fashion advertisers. It is no secret that many fashion companies use their considerable spending power to influence editors to feature their clothes in fashion shoots. In tough economic times, it is difficult to resist this pressure. It is a question of survival. And it is very hard to maintain artistic standards if so much emphasis is placed on showing a particular outfit by a particular designer in a particular way. I think that the capitulation of editors and publishers to this pressure threatens not only editorial integrity but long-term financial health as well. Audiences today are much more visually sophisticated, much more visually literate. They are bombarded with a steady stream of complex visual information via the media. Amidst all the inevitable mediocrity, there is a great deal of experimentation. By playing it safe, by setting creative standards so low, by being complacent, I think magazines run the risk of becoming irrelevant. Considering the technological changes of the last few years, it is only a matter of time before more immediate and effective forms of communication are developed to perform the simple task of showing clothes. Readers will no longer have to buy fashion magazines for that purpose.

Q: The process of making fashion editorials is a mystery to most people. Can you explain how it works at your magazine?
A: Twice a year, starting in September and March, ready-to-wear fashion collections are presented in Paris, Milan, London, and New York to an exclusive group of retail executives, store buyers, clients, and members of the editorial press. Seeing the clothes on the runway allows fashion editors to choose the outfits that they will feature in the magazine. These editors rarely photograph a look the way it is shown on the runway. They often combine and reinterpret the clothes of various designers to create something of their own and, in the process, define the point of view of the magazine. The internal structure of every publication is different. At *W* we have an editorial director, Patrick McCarthy, executive editor, Bridget Foley, a fashion director, Joe Zee, and a senior fashion editor, Alexandra White. As creative director, I choose photographers to work for the magazine on a project-by-project basis. After the collections are shown, we meet to discuss ideas for the coming season and to begin scheduling fashion shoots. It is important to anticipate how the work of each photographer will interact with the others. The mix of stories is crucial. It is a delicate balancing act. Each issue has its own narrative—its own character. So much is dependent on the pacing and sequencing.

For instance, I might juxtapose the mannered photographs of Steven Klein with the more immediate, spontaneous ones of Bruce Weber. Or I might contrast Juergen Teller's raw documentary style of photography with the meticulously polished work of Michael Thompson. Having the necessary material to do this underscores the importance of developing a stable of photographers with distinctive and varied points of view.

Q: Once you have decided on a particular photographer and editor how does the story develop?
A: The first step is to come up with an idea. At *W*, stories are rarely based on fashion trends. Sometimes, they are a response to a particular aspect of contemporary culture. Often, they are narrative, cinematic, and character driven. Other times, they are part non-fiction, as in a series of Juergen Teller photographs of Stephanie Seymour, taken at her home in suburban Connecticut. It is a hallucinogenic interpretation of the American Dream—one irony piled on top of another (fig. 2). The ex-supermodel girlfriend of rock icon Axl Rose marries polo-playing, art-collecting millionaire and raises beautiful children in a white-columned reproduction of George Washington's Mount Vernon, filled with eighteenth-century American antiques and Andy Warhol's *Electric Chairs*. The protagonist, Stephanie, models her own collection of vintage couture. One moment she is straddling a bearskin rug, wearing Balenciaga, circa 1961, and the next she is half dressed, legs apart, seated next to a giant stuffed alligator in the children's playroom, wrapped in Jean Patou, circa 1952.

In every story, no matter what the origin, the focus is on the woman wearing the clothes, not the other way around. The list of inspirations is long. Points of departure might include Stanley Kubrick's *A Clockwork Orange* (fig. 3), Playboy Playmates of the Month, Allen Ginsberg, Jeff Wall, Madame Yevonde, Eudora Welty, The American Family (fig. 4), or Francis Bacon (fig. 5). After discussions among the editor, photographer, and myself, these abstract ideas begin to take shape. Decisions are made about casting, clothing, location, hair, and makeup. These are our tools, the building blocks of every fashion story. Often, it is necessary to hire specialist teams such as lighting designers, set stylists, casting agents, and location scouts. There are often as many as twenty people on the set. In the end, no matter how good the idea, no matter how brilliant the team, it is the casting that makes or breaks a story. Unfortunately, it is not a science, and there is no rulebook. We have learned by experience that imperfection, more than anything else, makes a subject interesting. This reminds me of a comment Diane Arbus made about her portrait work: "You see someone on the street, and essentially what you notice about them is the flaw. It is just extraordinary that we should have been given these peculiarities. And, not content with what we're given, we create a whole other set. Our whole guise is like giving a sign to the world to think of us in a certain way."

Q: Among your list of inspirations, you mentioned Eudora Welty. That seems like a pretty odd choice for a fashion story. Tell us how that came about.
A: It happened during my first meeting with Bruce Weber. We just started to talk about the things that interested us. It turned out that we

were both fans of the writer Eudora Welty. Her revelatory introduction to William Eggleston's *The Democratic Forest* is one of the most lyrical pieces of writing about photography I have ever read. Who else could conjure up a "townful of Breughel peasants" in a photograph of "ivy crowding over a wall," or look at a close-up of a "great worldly peony" and see "a bloom so full-open and spacious that we could all but enter it, sit down inside and be served tea." Anyway, in the enthusiasm of the moment, Bruce and I made the decision to go to Jackson, Mississippi, and photograph Ms. Welty. We would take the model Kristen Owen and her two small children. We would bring clothes, not only for Kristen and the kids, but also for whoever else came our way. There would be no hairstylist or makeup artist. Kristen would do everything herself. It just so happened that Bruce knew a photographer living in Jackson who was a cousin of Eggleston's named Maude Schuyler Clay. By an extraordinary coincidence, it was Eggleston's aunt "Minnie Maude Schuyler" to whom his book *The Democratic Forest* had been dedicated. So we arranged for Maude to take us around. Very little was predetermined. At the University of Mississippi, we uncovered Melissa Miller, Sweetheart of Sigma Nu and Ole Miss Campus Favorite of 1997. We traveled to Port Gibson and photographed the cadets of the recently integrated Chamberlain–Hunt Military Academy. Bruce made a portrait of the poet Margaret Walker. From an announcement in the local newspaper, we learned about a Martin Luther King, Jr. Day celebration at the local high school. I remember sitting in the very back of the auditorium, watching Bruce, on his hands and knees, crawling up the steps to the stage, followed by his four assistants, waiting for the right moment to take a photograph of a young girl, singing alone, in a solitary spot of light. In the end, we met Eudora. I'm sure she had never heard of *W* magazine. Bruce had sent her examples of his work, and she graciously agreed to sit for us. It may have been one of the last portraits ever taken of her (fig. 6). Neither one of us will ever forget the moment she looked up and recognized the Rollieflex hanging from his neck. It reminded her of a camera that she once owned. Eudora proceeded to tell us stories about her days as a photographer in the 1930s when she went out into the Delta, to take pictures of rural farmworkers. At one point, I made a comment about how much it must have meant to the farmers to have their portrait taken by her. Without a moment's hesitation, she looked up, turned to me and explained: "No, *I* was the one who felt honored that they allowed *me*, a white woman, to take their picture."

Q: More than most other mainstream fashion magazines, *W* works with photographers primarily based in the art world. What is the reason?
A: It goes back to what I said about a magazine having as many different points of view as possible. I'm simply looking for someone with something to say, something to add to the dialogue. I don't see why that should be limited to so-called fashion photographers. There are fundamental differences between personal and editorial work. Working for a magazine involves the loss of control. The artistic objectives of the photographer and the commercial needs of the magazine are never the same. Ideally, the artist utilizes the contrivances of fashion photography—predetermined makeup, hairstyle, and clothing—to make a picture that succeeds on its own

terms, one with its own independent life. It is pointless to argue whether personal work is better or worse than editorial work; the truth is it is just different. For example, in Tina Barney's portrait of the art dealer Angela Westwater and her family everyone wears black. Along with the downcast eyes of the three central figures, the floating skull in the Mimmo Paladino painting, and the small bust of Antinuous (the drowned lover of the Emperor Hadrian), the preselected dark monochromatic clothing intensifies the gravity of the image. If this were one of Tina's personal works, the Westwaters would have chosen their own clothes and the result would have been very different, but not necessarily "better" (page 100).

Nowhere is the collaboration between hairstylist, makeup artist, fashion editor, and photographer more meticulously conceived than in the work of Inez van Lamsweerde and Vinoodh Matadin. In their portrait of the model Guinevere van Seenus, she wears pink lipstick, pink eye shadow, pink fingernail polish, and pink leggings—all to match the color of her exposed nipples. Even her pubic hair is dyed the same turquoise blue as the feather she holds in her hand. Her arms are encased in black leather. Her skin is alabaster. Her haircut is severe. Under the direction of Inez and Vinoodh, the fashion editor Alexandra White, the makeup artist Pat McGrath, and the hair stylist Eugene Souleiman pull out all the stops. Their work is critical to the success of this disturbing photograph (fig. 7). At the time, we weren't allowed to publish the picture because of its frontal nudity. Somehow, there was no objection to hanging it on a gallery wall when we later mounted a retrospective exhibition.

Q: There is a great deal of discussion about the blurring of lines between the fashion and art photograph. How do you feel about this?
A: What interests me is that while the debate goes on the fashion photographs themselves are being editioned and sold on the primary art market. Unlike the vintage work of Avedon, Penn, or Bourdin, these images are being sold contemporaneously with their publication in the magazines. No qualifications are made for the fact that these pictures were commissioned by fashion publications. In fact, many of the photographs by Philip-Lorca diCorcia and Juergen Teller in this exhibition have already passed into private collections. The only discernable difference between the fashion pictures that appear in the magazine and the art pictures sold by the gallery—besides format and context—is that one has fashion credits and the other doesn't.

Q: You commissioned several prominent contemporary artists to do portraits of Kate Moss for your September 2003 issue. Can you tell us about that project?
A: The idea grew out of a conversation I had with Kate. She told me that she had been asked by Lucian Freud to sit for a portrait. I thought it was significant that he chose her, an iconic fashion model, as his subject. Of all the women we have photographed over the years, Kate is the most compelling. She is complex, contradictory, and elusive. I thought that it would be interesting to see how contemporary artists responded to her. Because the artists I chose had never met Kate, their expectations were based on her public persona. I wondered how that would affect the outcome. Surprisingly, they produced the most revealing and unexpected images. Lisa Yuskavage photographed Kate

2. JUERGEN TELLER. "Home Alone," *W*, December 1999. 3. CRAIG MCDEAN. "A Clockwork Orange," *W*, May 1998. 4. PHILIP-LORCA DICORCIA. "A Perfect World," *W*, September 1999. 5. MARIO SORRENTI. "Deep Thoughts," *W*, January 1996

2

3

4

5

on her knees, bare-breasted, wearing candy-ball bikini bottoms and a Bardot blonde wig. To top it off, she is holding a dainty, turquoise-and-pink rosette-patterned teacup. In her sly and subversive way, Lisa nailed it: the sexually provocative, prim and proper woman/child. To make his series of daguerreotypes, Chuck Close placed her under an intense, unforgiving light. Every pore of her skin, every imperfection is exposed. It is the antithesis of the clichéd, digitally retouched fashion-magazine photograph. And yet Kate never looked more radiantly beautiful. Not long before the picture was taken, she had given birth to her first child. Somehow Chuck's portrait captures her, not as a supermodel, but as a mother—wiser, more mature, and less elusive.

Q: Have there been any times when a collaboration with an artist failed? A: I certainly wouldn't call it a failure, but there was one interesting project that never made it to the printer. I asked the artist Karen Kilimnik to make a set of drawings, based on runway shows in New York and Paris. I liked the way she combined written text and fashion imagery in her work. I remember one drawing, in particular, where she managed to include a Calvin Klein logo, a feathered tiara, a scruffy dog, and a portrait of Kate Moss (without her eyes or nose). To simplify matters, she added, in her own childlike scrawl, the words: "Pickled in priviledge [sic] and in family pathology, the Princess wasn't really qualified for anything but marriage." So I guess I should not have been surprised when I opened the box of drawings that I had commissioned and found, not designer dresses and supermodels, but Russian ballerinas and prancing white stallions. I thought it was brilliant. Unfortunately, Patrick McCarthy, the editorial director, overruled it. He didn't think that our readers would be able to make that much of a conceptual leap.

Q: In the exhibition, there are editorial stories from *W* magazine by Tina Barney, Philip-Lorca diCorcia, and Juergen Teller. Can you tell us about working with these photographers?
A: The series of portraits of the couture clients by Juergen Teller are among the most controversial—and important—photographs that we have ever published (pages 112–119). I only wish I had read Mr. Fairchild's memoir, *Chic Savages* (1989), before I asked Juergen to do the project. His words of warning would have dispelled my naïve illusions: "In the fashion business, it is almost against the law to tell the truth, and anyone who steps behind the silk curtain to show how raw the business is can expect a rough time." Couture collections are almost always photographed on beautifully lit, impossibly thin models, assuming unnatural poses, in carefully selected locations. Journalistically, it seemed a good idea to try to show something closer to the truth. Why not photograph the clothes on the women who actually wear them, who pay well into six figures for them. Not surprisingly, the European fashion houses felt differently. Their reaction was, to put it mildly, chilly. Many of them objected. They were interested in the fantasy, the illusion, the myth, and not in the reality. I was determined that if individuals didn't want to participate, we would do it without them; but there is one thing you can count on in the fashion industry: nobody wants to be left out. The clients were a mix of European aristocracy, minor royalty, and American money: Mafalda of Hesse, Anne de Bourbon, Marie-Chantal of Greece,

Jacqueline de Ribes, Ann Getty, and Deeda Blair. We put together the smallest team possible. Juergen, his young assistant—recruited from behind the counter at the local photo shop—and myself. The equipment list was short: two small 35mm Olympus auto-focus cameras with built-in flash and a few rolls of color film. We arrived at the house of each couturier at the appointed hour, looked around, found a spot to take the picture, and waited. I don't think the designers or their staffs knew what to make of our rag-tag team. When our model, the couture client, arrived, Juergen had her either sit or stand in our chosen spot. Then he popped a few rolls of film and it was all over. The experience was disorienting—part Edith Wharton, part Henry James, part Barbara Cartland. There was Marie-Chantal, formerly Marie-Chantal Miller, heiress to a duty-free shopping fortune, married to the Crown Prince of Greece, sitting alone in a white dress, in a white chair, on a white carpet, against a white wall, next to a white lampshade, looking lost. There was France Goldman, former beauty queen, married and living in Boca Raton, reportedly the single largest buyer of couture in the world, covered in jewels, dressed in over-the-top Lacroix, looking into the camera, with an unconvincing smile. And finally, Deeda Blair, the no-nonsense, helmet-haired wife of the former ambassador to Denmark and the Philippines, hand on hip, jaw clenched, dressed in sober black Yves Saint Laurent, staring into space. When the pictures were published, the reaction from the fashion world was not positive. They would have preferred to see their fifty-thousand dollar dresses on sample-size eighteen year olds. Mr. Fairchild was right.

I saw my first Tina Barney photograph, *Sunday New York Times*, hanging in a gallery at The Museum of Modern Art in 1983. Because of her bullet eye for detail, psychological insight, and sensitivity to the smallest gesture, I thought Tina would make interesting fashion pictures. When we first met, she let me know one thing right from the start: "I need to have interesting people who live in interesting locations." Her worst nightmare was a room with four bare walls. We decided to stick to familiar territory: families. We did two stories, the first in New York, the second in Dallas. Besides the Westwater portrait, there is one photograph I keep returning to over and over again. It is a picture she took of the three women of the Simmons family (fig. 8). It is interesting how this photograph relates to a series of pictures she took of herself and her friend Sheila over a period of six years, from 1983 to 1989. In those images, Tina sits comfortably in her club chair, wearing flowery chintz pants that match the flowery chintz slipcovers that match the flowery chintz curtains hanging on the wall. The setting is always the same: the Park Avenue apartment with dark green walls and worn oriental carpets. Tina is at home—in her world. The more you look at Tina's work, the more you notice the flowers. They run riot over everything—walls, furniture, and clothing. And then we come to the ladies of the Simmons family. No more chintz. The flowers are real. It is a Texas Technicolor explosion of pink, yellow, white, and red tulips, roses, and azaleas. Instead of the comfortably worn carpet we get a brand new, perfectly laid, immaculately maintained, suburban brick terrace: nothing handed down, nothing passed from one generation to the other. The mother, daughter, and step-daughter stand far apart, uprooted, each in her own world.

Philip-Lorca diCorcia and I have traveled all over the world collaborating on pictures for *W* magazine: Havana, São Paulo, Bangkok,

Saint Petersburg, and in New York. Rarely does a creative director have the opportunity to work with a photographer of such extraordinary talent. One of the reasons our collaboration has been so successful is that by the time we began working together diCorcia had spent years experimenting with the contrived photograph. Unlike many other artists, he was comfortable with the mechanics of the fashion picture, itself a contrivance. The really interesting thing to me about his fashion work is how it builds on the cinematic photography he did from the late 1970s through the early 1990s. Whether the subject was his brother Mario, his sister Auden, or twenty-one-year-old Eddie Anderson from Houston, Texas, each image was meticulously constructed and entirely self-contained. Although there was always an implied narrative, it was up to the viewer to complete the story. That all changed with the fashion work. For the first time, he was able to construct a story, picture-by-picture, scene-by-scene, developing character, and in the process creating a narrative. Few stories were less than twenty pages. After the final pictures were selected we would sit down at the computer screen with the design director Edward Leida and work on the layout. Countless variations would be tried, each with its own shade of meaning, each telling a different story. Individual pictures became part of the whole—their meaning dependent on their place in the overall sequence. Although we've never talked about it, and there are many historical precedents within photography-book publishing, I wonder if the experience of working on multiple-image fashion stories influenced his most recent project, *A Storybook Life*. In this book, the artist builds his story sequentially—intended as one long narrative, one body of work.

Q: One last question: As you explained, magazines today are under enormous financial pressure. What does that mean for the future of fashion photography?

A: There is only one thing that I am sure of—that you can't keep a lid on talent. It has a way of breaking through, often in the most unexpected places. How else could two young women barely out of their teens have become art directors of *Harper's Bazaar* in the hothouse years of the 1960s, and have turned out some of the most brilliant, innovative pages in the history of fashion photography. The photographs that Ruth Ansel and Bea Feitler published would undoubtedly be hanging on the walls of the Museum if this exhibition had been mounted thirty years ago. It is talent like theirs that rises to the top—no matter how difficult the economy or how merciless the commercial pressure. I have a copy of an article written by Richard Avedon in 1963, which appeared in *Graphis*, the influential Swiss graphic design magazine. His intention at the time was to write about Ruth and Bea, but the passage of forty years gives his words a particular resonance: "For the magazine, they have created an aesthetic: a dark, intelligent, introverted, beautiful woman. And, she not only dominates the pages of *Harper's Bazaar*, but has asserted a quality of beauty in the American woman that the woman herself had not previously recognized. And, on a very simple level this alone sells issues, cosmetics, clothes, etc. They have recognized trends in the whole spectrum of the arts and brought these to bear on their photographers. Conversely, they have influenced not only the world of fashion, but the world of advertising and films and through these the visual aesthetic of the country."

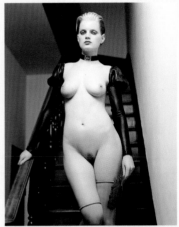

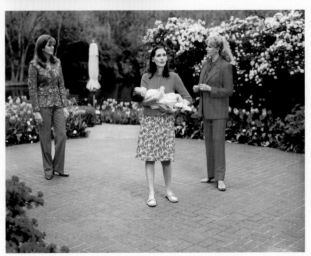

6. BRUCE WEBER. "Mississippi Yearning: Portrait of Eudora Welty," *W*, March 1997. 7. INEZ VAN LAMSWEERDE AND VINOODH MATADIN. Unpublished outtake from "Le Style Bohème," *W*, September 2003. 8 . TINA BARNEY. "Dallas," *W*, August 2001

list of plates

Note: The plate section is divided into two parts, "Cinematic Takes" and "Personal Fictions." Their works are identified by brief captions. This listing, arranged alphabetically by artist, gives a fuller description of the works: an individual title; title of editorial essay; place of publication and/or advertising campaign; stylist, art director, or fashion editor; medium; dimensions in inches and centimeters; credit line; and the page on which it is illustrated. Fashion photographs are made by teams of people; the following entries reflect only some of the major participants in the process.

TINA BARNEY (American, born 1945)

Julianne Moore and Family
From "New York Stories," *W*, October 1999
Stylist: Michel Botbol
Chromogenic color print, 48 x 60" (121.9 x 152.4 cm)
Courtesy the photographer and Janet Borden, Inc.
Page 100

The Reunion
From "New York Stories," *W*, October 1999
Stylist: Michel Botbol
Chromogenic color print, 48 x 60" (121.9 x 152.4 cm)
Courtesy the photographer and Janet Borden, Inc.
Page 101

The Red Lipstick
From "New York Stories," *W*, October 1999
Stylist: Michel Botbol
Chromogenic color print, 48 x 60" (121.9 x 152.4 cm)
Courtesy the photographer and Janet Borden, Inc.
Page 101

Joan Didion
From "New York Stories," *W*, October 1999
Stylist: Michel Botbol
Chromogenic color print, 48 x 60" (121.9 x 152.4 cm)
Courtesy the photographer and Janet Borden, Inc.
Page 102

The Mardens
From "New York Stories," *W*, October 1999
Stylist: Michel Botbol
Chromogenic color print, 48 x 60" (121.9 x 152.4 cm)
Courtesy the photographer and Janet Borden, Inc.
Page 103

The Pool Construction
From "New York Stories," *W*, October 1999
Stylist: Michel Botbol
Chromogenic color print, 48 x 60" (121.9 x 152.4 cm)
Courtesy the photographer and Janet Borden, Inc.
Pages 104–105

CEDRIC BUCHET (French and Danish, born France, 1974)

Six untitled photographs from Prada advertising campaign
Spring/Summer 2001
Stylist: Alastair Mackui
Art Director: David James
Chromogenic color prints, each approx. 30 x 40"
(76.2 x 101.6 cm)
Courtesy the photographer and Walter Schupfer
Management Corporation
Pages 34–41

PHILIP-LORCA DICORCIA (American, born 1953)

Twelve untitled photographs from "Cuba Libre," *W*,
March 2000
Stylist: Joe Zee
Chromogenic color prints, each approx. 30 x 40"
(76.2 x 101.6 cm)
Courtesy the photographer and Pace/MacGill Gallery,
New York
Pages 42–53

NAN GOLDIN (American, born 1953)

Three Friends at Plunge Pool, Russian Baths, New York City
From "Masculine/Feminine," *View*, 1985
Fashion Editor: Mary Peacock
Silver dye bleach print (Cibachrome), 20 x 24"
(50.8 x 60.9 cm)
Courtesy the photographer and Matthew Marks Gallery
Page 86

Rebecca Fastening Her Bra, Russian Baths, New York City
From "Masculine/Feminine," *View*, 1985
Fashion Editor: Mary Peacock
Silver dye bleach print (Cibachrome), 40 x 30"
(101.6 x 76.2 cm)
Courtesy the photographer and Matthew Marks Gallery
Page 87

Untitled, Russian Baths, New York City
From "Masculine/Feminine," *View*, 1985
Fashion Editor: Mary Peacock
Silver dye bleach print (Cibachrome), 30 x 40"
(76.2 x 101.6 cm)
Courtesy the photographer and Matthew Marks Gallery
Page 88

C.Z. Lying in Sauna, Russian Baths, New York City
From "Masculine/Feminine," *View*, 1985
Fashion Editor: Mary Peacock
Silver dye bleach print (Cibachrome), 20 x 24"
(50.8 x 60.9 cm)
Courtesy the photographer and Matthew Marks Gallery
Page 89

*Two Friends in Boys' Underwear, Russian Baths,
New York City*
From "Masculine/Feminine," *View*, 1985
Fashion Editor: Mary Peacock
Silver dye bleach print (Cibachrome), 20 x 24"
(50.8 x 60.9 cm)
Courtesy the photographer and Matthew Marks Gallery
Page 90

*Three Friends on Beds after Sauna, Russian Baths,
New York City*
From "Masculine/Feminine," *View*, 1985
Fashion Editor: Mary Peacock
Silver dye bleach print (Cibachrome), 20 x 30"
(50.8 x 76.2 cm)
Courtesy the photographer and Matthew Marks Gallery
Page 91

C.Z. on the Bed, Russian Baths, New York City
From "Masculine/Feminine," *View*, 1985
Fashion Editor: Mary Peacock
Silver dye bleach print (Cibachrome), 20 x 24"
(50.8 x 60.9 cm)
Courtesy the photographer and Matthew Marks Gallery
Page 91

*Friends Changing in Locker Room, Russian Baths,
New York City*
From "Masculine/Feminine," *View*, 1985
Fashion Editor: Mary Peacock
Silver dye bleach print (Cibachrome), 20 x 24"
(50.8 x 60.9 cm)
Courtesy the photographer and Matthew Marks Gallery
Page 91

*Four Friends in Underwear, Russian Baths,
New York City*
From "Masculine/Feminine," *View*, 1985
Fashion Editor: Mary Peacock
Silver dye bleach print (Cibachrome), 20 x 24"
(50.8 x 60.9 cm)
Courtesy the photographer and Matthew Marks Gallery
Page 92

Untitled, Russian Baths, New York City
From "Masculine/Feminine," *View*, 1985
Fashion Editor: Mary Peacock
Silver dye bleach print (Cibachrome), 20 x 30"
(50.8 x 76.2 cm)
Courtesy the photographer and Matthew Marks Gallery
Page 93

Suzanne on the Toilet, Russian Baths, New York City
From "Masculine/Feminine," variant of image
in *View*, 1985
Fashion Editor: Mary Peacock
Silver dye bleach print (Cibachrome), 40 x 30"
(101.6 x 76.2 cm)
Courtesy the photographer and Matthew Marks Gallery
Page 93

SIMON LEIGH (British, born 1963)

Six untitled photographs from "Oh de Toilette"
Tank 3, no. 1, 2002
Chromogenic color prints, each 24 x 24" (60.9 x 60.9 cm)
Printed by Metro Imaging
Courtesy the photographer
Pages 94–99

GLEN LUCHFORD (British, born 1968)

Seven untitled photographs from Prada advertising
campaign
Fall/Winter 1997
Stylist: Alexandra White
Art Director: David James
Chromogenic color prints (Ektacolor), each approx.
30 x 40" (76.2 x 101.6 cm)
Courtesy the photographer and Art + Commerce
Pages 68–69, 72–75

Untitled photograph from Prada advertising campaign
Spring/Summer 1998
Stylist: Alexandra White
Art Director: David James
Chromogenic color print (Ektacolor), approx. 30 x 40"
(76.2 x 101.6 cm)
Courtesy the photographer and Art + Commerce
Pages 70–71

STEVEN MEISEL (American)

Eight untitled photographs from "The Good Life"
Published in *Vogue Italia*, October 1997
Stylist: Brana Wolf
Chromogenic color prints (Ektacolor), each approx.
 20 x 24" (50.8 x 60.9 cm) or 24 x 20" (60.9 x 50.8 cm)
Courtesy the photographer and Art + Commerce
Pages 106–111

CINDY SHERMAN (American, born 1954)

Untitled #277
From "The New Cindy Sherman Collection,"
 Harper's Bazaar, May 1993
Chromogenic color print, approx. 49 x 73" (124.5 x 185.4 cm)
Collection Sondra and David S. Mack
Page 54

Untitled #299
Comme des Garçons advertising campaign
Spring/Summer 1994
Chromogenic color print, 48 7/8 x 32 15/16"
 (124.1 x 83.7 cm)
Collection Gary Sibley
Page 55

Untitled #297
Comme des Garçons advertising campaign
Spring/Summer 1994
Chromogenic color print, approx. 50 1/8 x 33"
 (127.3 x 83.8 cm)
Private collection, New York
Page 56

Untitled #133
Dorothée Bis advertising campaign
1984
Chromogenic color print, 71 1/4 x 47 1/2"
 (181 x 120.7 cm)
The Marieluise Hessel Collection on permanent loan to
 the Center for Curatorial Studies, Bard College,
 Annandale-on-Hudson, New York
Page 57

Untitled #132
Dorothée Bis advertising campaign
1984
Chromogenic color print, 69 x 47" (175.3 x 119.4 cm)
Collection John Cheim
Page 58

Untitled #279
From "The New Cindy Sherman Collection," *Harper's
 Bazaar*, May 1993
Chromogenic color print, 64 x 48" (162.6 x 121.9 cm)
Ann and Mel Schaffer Family Collection
Page 59

Untitled #281
From "The New Cindy Sherman Collection," *Harper's
 Bazaar*, May 1993
Chromogenic color print, approx. 53 x 35"
 (134.6 x 88.9 cm)
Private collection, Long Island
Page 60

Untitled #278
From "The New Cindy Sherman Collection," *Harper's
 Bazaar*, May 1993
Chromogenic color print, approx. 73 x 49"
 (185.4 x 124.5 cm)
Collection Rita Krauss
Page 61

MARIO SORRENTI (American, born Italy, 1971)

Diary, 1994–95
Bound book with photographs, drawings, and writing,
 approx. 16 1/4 x 10 1/8 x 2" (41.3 x 25.7 x 5.1 cm)
Courtesy the photographer and Art Partner, New York
Pages 78–79

Untitled
From "One," *Another Magazine*, no. 1, Autumn/Winter 2001
Stylist: Camilla Nickerson
Chromogenic color print, approx. 48 x 60" (121.9 x 152.4 cm)
Courtesy the photographer and Art Partner, New York
Page 80

Hestone, Self-Portrait
From "One," *Another Magazine*, no. 1, Autumn/Winter 2001
Stylist: Camilla Nickerson
Chromogenic color print, approx. 48 x 60" (121.9 x 152.4 cm)
Courtesy the photographer and Art Partner, New York
Page 81

Lucie and Alma
From "One," *Another Magazine*, no. 1, Autumn/Winter 2001
Stylist: Camilla Nickerson
Chromogenic color print, approx. 48 x 60" (121.9 x 152.4 cm)
Courtesy the photographer and Art Partner, New York
Page 82

Lola and Vito
From "One," *Another Magazine*, no. 1, Autumn/Winter 2001
Stylist: Camilla Nickerson
Chromogenic color print, approx. 48 x 60" (121.9 x 152.4 cm)
Courtesy the photographer and Art Partner, New York
Page 82

Happy Hour
From "One," *Another Magazine*, no. 1, Autumn/Winter 2001
Stylist: Camilla Nickerson
Chromogenic color print, approx. 48 x 60" (121.9 x 152.4 cm)
Courtesy the photographer and Art Partner, New York
Page 83

Diary, 1997–98
Bound book with photographs, drawings, and writing,
 approx. 15 3/4 x 10 5/8 x 2" (40 x 27 x 5.1 cm)
Courtesy the photographer and Art Partner, New York
Pages 84–85

LARRY SULTAN (American, born 1946)

Nine untitled photographs from "Visiting Tennessee,"
Kate Spade advertising campaign
Fall/Winter 2002
Stylist: Karen Patch
Chromogenic color prints (Ektacolor), each sheet
 20 x 16" (50.8 x 40.6 cm)
Courtesy the photographer and Janet Borden, Inc.
Pages 120–127

JUERGEN TELLER (German, born 1964)

The Clients, Haute Couture: Marie-Chantal of Greece, Paris
From "The Clients," *W*, March 1999
Chromogenic color print, 73 x 50" (185.4 x 127 cm)
Courtesy the artist and Lehmann Maupin Gallery, New York
Page 112

The Clients, Haute Couture: France Goldman, Paris
From "The Clients," *W*, March 1999
Chromogenic color print, 73 x 50" (185.4 x 127 cm)
Courtesy the artist and Lehmann Maupin Gallery, New York
Page 113

The Clients, Haute Couture: Jacqueline de Ribes, Paris
From "The Clients," *W*, March 1999
Chromogenic color print, 73 x 50" (185.4 x 127 cm)
Courtesy the artist and Lehmann Maupin Gallery, New York
Page 114

The Clients, Haute Couture: Anne de Bourbon, Paris
From "The Clients," *W*, March 1999
Chromogenic color print, 73 x 50" (185.4 x 127 cm)
Courtesy the artist and Lehmann Maupin Gallery, New York
Page 115

The Clients, Haute Couture: Mafalda of Hesse, Paris
From "The Clients," *W*, March 1999
Chromogenic color print, 73 x 50" (185.4 x 127 cm)
Courtesy the artist and Lehmann Maupin Gallery, New York
Page 116

The Clients, Haute Couture: Myriam Lafon, Paris
From "The Clients," *W*, March 1999
Chromogenic color print, 73 x 50" (185.4 x 127 cm)
Courtesy the artist and Lehmann Maupin Gallery, New York
Page 117

The Clients, Haute Couture: Ann Getty, Paris
From "The Clients," *W*, March 1999
Chromogenic color print, 73 x 50" (185.4 x 127 cm)
Courtesy the artist and Lehmann Maupin Gallery, New York
Page 118

The Clients, Haute Couture: Deeda Blair, Paris
From "The Clients," *W*, March 1999
Chromogenic color print, 73 x 50" (185.4 x 127 cm)
Courtesy the artist and Lehmann Maupin Gallery, New York
Page 119

ELLEN VON UNWERTH (German, born 1954)

Six untitled photographs from Alberta Ferretti
 advertising campaign
Fall/Winter 1995
Stylist: Alice Gentilucci
Gelatin silver prints, each approx. 19 1/2 x 14"
 (50.2 x 35.6 cm)
Courtesy the photographer and Art + Commerce
Pages 62–67

bibliography

The information given below for each photographer refers primarily to his or her work in the field of fashion photography. In each category, Editorials, Advertising Campaigns, Publications, and Films, the entries reflect a selection of titles and are by no means complete. Editorials and advertising campaigns were selected by the photographers; publications were compiled by the curators. The listings within each category are arranged chronologically.

TINA BARNEY

Born New York, New York, 1945
The Sun Valley Center for Arts and Humanities, B.A., 1979

Editorials

"Art Lovers" (Leo Castelli), *W*, September 1998: 362–363
"A Clean, Well-Lighted Room" (John Dugdale), *Nest: A Quarterly of Interiors*, Fall 1999: 152–162
"New York Stories," *W*, October 1999: 300–312
"The Dear Hunter" (Tom Cary), *Nest: A Quarterly of Interiors*, Spring 2000: 154–164
"Dallas," *W*, August 2001: 150–164
"Mexico City," *W*, June 2003: 144–153
"Pilgrim's Progress" (Dianne Pilgrim), *Nest: A Quarterly of Interiors*, Summer 2003: 130–142

Publications

Tina Barney and Constance Sullivan. *Friends and Relations: Photographs by Tina Barney*. Washington, D.C.: Smithsonian Institution Press, 1991
Tina Barney and Andy Grundberg. *Theater of Manners: Tina Barney Photographs*. New York and Zurich: Scalo, 1997
Catherine Evans. *Photographic Tableaux: Tina Barney's Family Album*. Columbus, Ohio: Columbus Museum of Art, 1999

CEDRIC BUCHET

Born Paris, France, 1974

Editorials

"Shattered," *Big* (Celebration Issue), no. 37, 2001: 36–41
"Great Outdoor Influence," *Self Service*, Fall/Winter 2001: 264–271
"Remaking Makebelieve," *Dazed & Confused*, no. 88, April 2002: 130–143
"Flamingos Are So Red They Can Hide from Their Predators in the Sunset," *Dazed & Confused*, no. 95, November 2002: 154–167
"Missing," *Crash*, no. 23, Fall 2002: cover, 9–17
Big (Transatlantic Issue), 2002: 76–89
"Winter Collections/Reports for Women," *Another Magazine*, no. 5, Fall/Winter 2003: 184–203
"Neue Ideen für Ihren Kopf," *Zoo*, November 2003: 180–184

Advertising Campaigns

Sega, 2000
Prada, Spring/Summer 2001
Max Mara, 2003
Hewlett-Packard, 2003

PHILIP-LORCA DICORCIA

Born Hartford, Connecticut, 1953
School of the Museum of Fine Arts, Boston, Diploma, 1974
School of the Museum of Fine Arts, Boston, Post-Graduate Certificate, 1975
Yale University, New Haven, Connecticut, M.F.A., 1979

Editorials

"The Individualists," *Harper's Bazaar*, September 1997: 448–452
"Berlin Story," *Vogue Hommes International*, Spring/Summer 1998: 128–138
"Grand Illusion," *W*, September 1998: 316–335
"Freeze Frame," *W*, December 1998: 252–259
"A Perfect World," *W*, September 1999: 372–398
"Cuba Libre," *W*, March 2000: 421–449
"Stranger in Paradise," *W*, September 2000: 446–469
"Bangkok," *W*, September 2001: 504–522

Advertising Campaigns

Piazza Sempione, Spring/Summer 2000
Fendi, Fall/Winter 2001

Publications

Peter Galassi. *Philip-Lorca diCorcia*. New York: The Museum of Modern Art, 1995
Philip-Lorca diCorcia. *Streetwork, 1993–1997: Photographs by Philip-Lorca diCorcia*. Salamanca: Universidad de Salamanca, 1998
Philip-Lorca diCorcia: Heads. Essay by Luc Sante. London: Thames & Hudson, 2001
Ulrich Lehmann and Gilles Lipovetsky. *Chic Clicks: Commerce and Creativity in Contemporary Fashion Photography*. Boston: Institute of Contemporary Art; New York: Distributed Art Publishers, 2002
Philip-Lorca diCorcia: A Storybook Life. Santa Fe: Twin Palms Publishers, 2003

NAN GOLDIN

Born Washington, D.C., 1953
Image Works, Cambridge, Massachusetts, Fifth Year Certificate, 1977
School of the Museum of Fine Arts/Tufts University, Boston, B.F.A/B.A., 1977

Editorials

"While Manny's Locked Up," *The New York Times Magazine*, August 14, 1994: 26–34
"James Is a Girl," *The New York Times Magazine*, February 4, 1996: cover, 26–34
"Le Monde Selon Nan Goldin," *Paris Vogue*, October 2001: 356–368
"Paris: Backstage Fall/Winter 2002–03," *V*, no. 18, July/August 2002: 48–56
"Stella McCartney, Nan Goldin, Kate Moss," British *Vogue*, October 2001: 346–358

Advertising Campaigns

"Naked New York," Matsuda, Fall 1996
SNCF Transilien France Railway, 2002, 2003

Publications

Nan Goldin. *The Ballad of Sexual Dependency: Photographs by Nan Goldin*. Eds. Marvin Heiferman, Mark Holborn, and Suzanne Fletcher. New York: Aperture Foundation, 1986
Nan Goldin. *Cookie Mueller: Photographs*. New York: Pace/MacGill Gallery, 1991
Nan Goldin, David Armstrong, and Walter Keller. *Nan Goldin: The Other Side*. New York: Scalo, 1993

Nan Goldin, *Desire by Numbers*. Text by Klaus Kertess. San Francisco: Artspace Books, 1994
Nan Goldin, Walter Keller, and Hans Werner Holzwarth. *A Double Life: Nan Goldin, David Armstrong*. New York and Zurich: Scalo, 1994
Elisabeth Sussman, Nan Goldin, David Armstrong, and Hans Werner Holzwarth. *Nan Goldin: I'll Be Your Mirror*. New York: Whitney Museum of American Art; Zurich: Scalo, 1996
Gigi Giannuzzi, Nan Goldin, and Guido Costa. *Nan Goldin, Guido Costa: Ten Years After: Naples 1986–1996*. New York and Zurich: Scalo, 1998
Nan Goldin and Taka Kawachi. *Nan Goldin: Couples and Loneliness*. Kyoto: Korinsha, 1998
Nan Goldin: Recent Photographs. Text by Dana Fris-Hansen. Houston: Houston Contemporary Arts Museum, 1999
Nan Goldin, Lisa Liebman, and Guido Costa. *Nan Goldin 55*. London: Phaidon, 2001
Paulette Gagnon and Éric Mézil. *Nan Goldin*. Montreal: Musée d'Art Contemporain de Montreal, 2003
Nan Goldin. *The Devil's Playground*. London: Phaidon, 2003

SIMON LEIGH

Born Thames, Oxfordshire, Great Britain, 1963
Middlesex Polytechnic, London, B.A., 1987
University of Westminster, London, B.A., 1995

Editorials

"Interiors," *Tank* 1, no. 4, 1999: 106–115
"Waiting Waiting," *Tank* 1, no. 6, 1999: 250–258
"Messy Rooms," *Tank* 1, no. 9, 2000: 126–136
"Tea Leaf (with Bump)," *Tank* 2, no. 2, 2001: 148–172
"Celebrity Special," *Putt*, no. 1, 2001: 68–81
"Oh de Toilette" *Tank* 3, no. 1, 2002: 144–148
"Carry on Regardless," *Putt*, no. 2, 2002: 78–87
"Field of Dreams," *Tank* 3, no. 4, 2002: 94–102

Advertising Campaigns

Absolut Vodka, in collaboration with Bump, 2000
Pringle "flick book," Spring/Summer 2002

Publications

Masoud Golsorkhi and Andreas Laeufer, eds. *Best of Tank*. London: Thames & Hudson, 2002
Katia Hadidian. *OXO One for All*. London: Tank Publications, 2002
Andrew Tucker. *Cut: The New Fashion*. London: Thames & Hudson, 2004

GLEN LUCHFORD

Born Brighton, Great Britain, 1968

Editorials

"City Slick" (Kate Moss in New York), *Harper's Bazaar*, September 1994: 444–451
"Serious Fun," *Mirabella*, September 1994: 170–179
"Fashion's Great Little," *Vogue Italia*, August 2000: 222–239
"Ritual," *Another Magazine*, no. 3, 2002: 252–263
"Variation on Gold," *Vogue Italia*, March 2002: 622–631
"Skincare: Back to Youth," *Vogue Italia*, October 2002: 435–444
"Poupée," *Paris Vogue*, April 2003: 186–197

Advertising Campaigns

Prada, Fall/Winter 1997
Prada, Spring/Summer 1998
Miu Miu, Spring/Summer 1998
Yves Saint Laurent, Spring/Summer 2003

Publications

Charlotte Cotton. *Imperfect Beauty: The Making of Contemporary Fashion Photographs*. London: V & A Publications, 2000

Ulrich Lehmann and Gilles Lipovetsky. *Chic Clicks: Commerce and Creativity in Contemporary Fashion Photography*. Boston: Institute of Contemporary Art; New York: Distributed Art Publishers, 2002

Glen Luchford, Jenny Saville, and Katherine Dunn. *Jenny Saville & Glen Luchford: Closed Contact*. New York: Gagosian Gallery, 2002

Film

Glen Luchford. "Here to Where," 2001. 35mm, 90 min. Holy Cow Productions, London, 2001.

STEVEN MEISEL

Born New York, New York
Parsons School of Design, New York

Editorials

"Jam Session," *Interview*, February 1990: 98–108
"Time for Change," *Vogue*, October 1992: 271–297
"Grunge and Glory," *Vogue*, December 1992: 254–272
Per Lui, July 1993: entire issue
"Dance Marathon," *Vogue Italia*, March 1997: 436–468
"An Interpretation" (Alex Katz Story), *Vogue Italia*, July 1997: 158–192
"Series 5—Life," *Vogue Italia*, July 2000: 181–258
"Series 6—Outer Limits," *Vogue Italia*, August 2000: 144–170
"Day for Night," *Vogue Italia*, September 2002: 150–178
"Topanga Rose," *Vogue Italia* (supplement), September 2003: 134–158

Advertising Campaigns

CK One, 1994
Dolce and Gabbana, Fall/Winter 1997
Versace, Fall/Winter 1998
D & G, Spring/Summer 1999
Versace, Fall/Winter 2000
Yves Saint Laurent Opium, 2001
Prada, Fall/Winter 2002
Prada, Spring/Summer 2003
Dolce and Gabbana, Fall/Winter 2003
Valentino, Fall/Winter 2003

Publications

William Ewing et al., *The Idealizing Vision: The Art of Fashion Photography*. New York: Aperture, 1991
Steven Meisel: Fotografie. New York and Düsseldorf: Te Neues Publishing, 2003

CINDY SHERMAN

Born Glen Ridge, New Jersey, 1954
State University College at Buffalo, New York, B.A., 1976

Editorials

"The New Cindy Sherman Collection," *Harper's Bazaar*, May 1993: 144–149

Advertising Campaigns

Dorothée Bis, 1984
Comme des Garçons, Spring/Summer 1994

Publications

Els Barents. *Cindy Sherman*. Amsterdam: Stedelijk Museum, 1982

Cindy Sherman. *Currents 20: Cindy Sherman*. Essay by Jack Cowart. St. Louis: The St. Louis Art Museum, 1983

Peter Schjeldahl and I. Michael Danoff. *Cindy Sherman*. New York: Pantheon Books, 1984

Peter Schjeldahl and Lisa Phillips. *Cindy Sherman*. New York: Whitney Museum of American Art, 1987

Arthur C. Danto. *Cindy Sherman: Untitled Film Stills*. New York: Rizzoli, 1990

Arthur C. Danto. *History Portraits*. New York: Rizzoli, 1991

Dean Sobel. *Currents 18: Cindy Sherman*. Milwaukee: Milwaukee Art Museum, 1991

Rosalind E. Krauss. *Cindy Sherman: 1975–1993*. Essay by Norman Bryson. New York: Rizzoli, 1993

Christa Schneider. *Cindy Sherman: History Portraits*. Munich: Schirmer/Mosel, 1995

Amanda Cruz, Elizabeth A. T. Smith, and Amelia Jones. *Cindy Sherman: Retrospective*. Los Angeles: Museum of Contemporary Art; Chicago: Museum of Contemporary Art, 1997

Cindy Sherman: The Complete Untitled Film Stills. New York: The Museum of Modern Art, 2003

Lisa Phillips, ed. *Cindy Sherman: Centerfolds 1981*. New York: Skarstedt Fine Art, 2003

Rochelle Steiner. *Cindy Sherman*. London: Serpentine Gallery, 2003

MARIO SORRENTI

Born Naples, Italy, 1971

Editorials

"Deep Thoughts," *W*, January 1996: 62–75
"Junya Watanabe," *Visionaire*, no. 25, 1998: sec. 2
"Martin Margiela," *i-D* (Very Blue Issue), August 1998: 106
"Swoon," *The Face*, April 1999: 94–101
"Playmates à la Mode," *W*, January 2000: 84–91
"Berlin Story," *W*, July 2000: 62–87
"Untitled 1," *i-D* (Original Issue), September 2000: 266–273
"One," *Another Magazine*, no. 1, Autumn/Winter 2001: 184–197
"Mario's Way," *Arena Hommes Plus* (Free Spirit Issue), Spring/Summer 2001: 260–279
"Body of Evidence," *Harper's Bazaar*, July 2003: 74–81

Advertising Campaigns

Calvin Klein Obsession, 1992–present
Dolce and Gabbana, Spring/Summer 1994
Yves Saint Laurent, Spring/Summer 1999
Jil Sander, Spring/Summer 2000
Emmanuel Ungaro, Spring/Summer 2000
Atsuro Tayama, Spring/Summer 2001
Missoni, Spring/Summer 2001
Atsuro Tayama, Fall/Winter 2002
Calvin Klein, Fall/Winter 2003
Calvin Klein, Spring/Summer 2003

Publications

Mario Sorrenti. *Kate*. London: Pavilion Books, 1995

Charlotte Cotton. *Imperfect Beauty: The Making of Contemporary Fashion Photographs*. London: V & A Publications, 2000

Mario Sorrenti, Alex Wiederin, and Mary Frey, eds. *Mario Sorrenti: The Machine*. Göttingen: Steidl/Editions Stromboli, 2001

Mario Sorrenti. *Tomo (Davide Sorrenti)*. Modena, Italy: Sartoria Communicazione, 2001

LARRY SULTAN

Born Brooklyn, New York, 1946
University of California, Berkeley, B.A., 1968
San Francisco Art Institute, M.F.A., 1973

Editorials

"Steamy Suburbs," *Vogue Hommes International*, Spring/Summer 1999: 130–144
"Adult Education," *Detour*, April 2000: 132–144
"The Battle," *The New York Times Magazine*, November 12, 2000: 68–77
"The Parallel Universe," *The New York Times Magazine*, November 12, 2000: 98–99
"Days of Their Lives," *GQ*, June 2001: 134–155
"Set for Seduction," *Wallpaper*, May/June 2003: 104–109
"Giglio Revisited," *Esquire*, February 2003: 98–108

Advertising Campaigns

Nike/Air Jordan, 2001
Stüssy, Spring/Summer 2002
Kate Spade, Fall/Winter 2002
American Express (UK), 2003

Publications

Larry Sultan and Mike Mandel. *Evidence*. Greenbrae, Calif.: Clatworthy Colorvues, 1977.

Larry Sultan. *Pictures from Home*. New York: Harry N. Abrams, 1992

Ulrich Lehmann and Gilles Lipovetsky. *Chic Clicks: Commerce and Creativity in Contemporary Fashion Photography*. Boston: Institute of Contemporary Art; New York: Distributed Art Publishers, 2002

JUERGEN TELLER

Born Erlangen, Germany, 1964
Bayerische Staatslehranstalt für Fotographie, Munich, Germany, 1984–86

Editorials

"Paradise Lost Romania," *i-D* (Paradise Issue), Spring 1990: 46–55
"White" (Uno Stile), *Vogue Italia* (supplement), September 1995: 200–214.
"Mode und Moral," *Süddentshe Zeitung*, March 15, 1996: cover, 70–77
"Editor at Large," *W*, February 1999: 136–166
"The Clients," *W*, March 1999: 430–443
"Home Alone," *W*, December 1999: 256–283
"Portrait," *Index* (supplement), November/December 2000: 22–31
"Vive la Mode," *W*, December 2002: 232–283
"Venetia Scott," *Self Service*, Spring/Summer 2002: 168–175
"Vegas Story," *W*, September 2003: 480–497

Advertising Campaigns

Comme des Garçons (Anna Pawlowski), 1991
Yves Saint Laurent (Kate Moss), Spring/Summer 1998
Helmut Lang, Fall/Winter 2000
Calvin Klein Kids, Spring/Summer 2000
Marc Jacobs Shoes (Stephanie Seymour), Fall/Winter 2001
Marc Jacobs Men (Jarvis Cocker), Fall/Winter 2002
Marc Jacobs (Winona Ryder), Spring/Summer 2003
Marc Jacobs Men (Roni Horn), Spring/Summer 2003
Marc Jacobs (Thurston Moore), Fall/Winter 2003

Publications

William Ewing et al. *The Idealizing Vision: The Art of Fashion Photography*. New York: Aperture, 1991

Michael Rutschky and Juergen Teller. *Der Verborgene Brecht Ein Berliner Stadtrundgang.* New York and Zurich: Scalo, 1997

Juergen Teller. New York: Taschen, October 1999

Juergen Teller: Go-Sees. New York and Zurich: Scalo, 1999

Charlotte Cotton. *Imperfect Beauty: The Making of Contemporary Fashion Photographs.* London: V & A Publications, 2000

Juergen Teller: Tracht. New York: Distributed Art Publishers, 2001

Marion de Beaupré, Stéphane Baumet, and Ulf Poschardt. *Archaeology of Elegance, 1980–2000: 20 Years of Fashion Photography.* New York: Rizzoli, 2002

Juergen Teller and Stephanie Seymour. *Juergen Teller, Stephanie Seymour, More.* Göttingen: Steidl, 2002

Juergen Teller. *Two Porkchops with a Dumpling and One Children's Portion of Schnitzel with Fries.* Göttingen: Steidl, 2003

Juergen Teller, Ute Eskildsen, Tracey Emin, and Ulf Poschardt. *Juergen Teller: Märchenstüberl.* Göttingen: Steidl, 2003

ELLEN VON UNWERTH
Born Frankfurt, Germany, 1954

Editorials
"The Sisters," *Vogue Italia,* August 1990: 198–212

"A Bikini Story," *Interview,* June 1991: 90–97

"Dietrich Chic," *Vogue,* September 1992: 502–517

"Isn't It Romantic?" *Vogue,* February 1993: 258–270

"Nadja," *The Face,* September 1994: cover, 36–42

"Coney Island," *The Face,* October 1995: 156–163

"This Side of Paradise," *Vogue,* September 1996: 502–517

"Picnic," *Vogue Italia,* October 1996: 554–571

"Short Dresses That Go," *Vogue Italia,* October 2001: 730–754

"Gipfel Treffen," German *Vogue,* August 2003: 174–185

Advertising Campaigns
Guess (Claudia Schiffer), 1989

Miu Miu (Drew Barrymore), Spring/Summer 1995

Wonderbra (Eva Herzigova), Spring/Summer 1995

Guess (Lonneke), 1996

Forum, Fall/Winter 1996

Adidas, "Athletes," 1997

Miss Sixty (Nathalia), Spring/Summer 2001

Diesel, Spring/Summer 2001

Victoria's Secret, Spring/Summer 2003

Tommy Hilfiger (David Bowie and Iman), Spring/Summer 2004

Publications
William Ewing et al., *The Idealizing Vision: The Art of Fashion Photography.* New York: Aperture, 1991

Ellen von Unwerth. *Snaps.* Sante Fe: Twin Palms Press, 1994

Ellen von Unwerth. *Couples.* New York and Düsseldorf: Te Neues Publishing, 1999

Ellen von Unwerth. *Wicked.* Munich: Schirmer/Mosel, 1999

Marion de Beaupré, Stéphane Baumet, and Ulf Poschardt. *Archaeology of Elegance, 1980–2000: 20 Years of Fashion Photography.* New York: Rizzoli, 2002

Ellen von Unwerth. *Revenge.* New York: Staley-Wise Gallery; Santa Fe: Twin Palms Press, 2003

photograph
credits

The photographs in the plate section of this book have been provided, for the most part, by the artists or custodians of the works. The photographers or their representatives hold the copyrights to these works, which may not be reproduced in any form without the permission of the copyright holders. Further information on the sources of the plates can be found in the List of Plates on page 138.

The following credits for works reproduced elsewhere in the book appear at the request of the artists or their representatives. Unless otherwise noted, references are to page numbers.

© Richard Avedon: 17 bottom right.

© 1992 Benetton Group S.p.A.: 21 center right.

Courtesy Janet Borden, Inc.: 137 bottom.

© The Estate of Brassaï: 14 bottom left.

© Guy Bourdin, courtesy Pace/MacGill Gallery, New York: 17 top right and center right.

© 1951 (renewed 1979) by Condé Nast Publications Inc.: 14 top left.

Courtesy Philip-Lorca diCorcia : 135 bottom left.

© William Klein, courtesy Howard Greenberg Gallery, New York: 14 top right.

Courtesy Leon Constantiner/Staley–Wise Gallery: 14 bottom right.

Courtesy Mikael Jansson and Wilson/Wenzel: 21 center right.

Courtesy Mikael Jansson, Wilson/Wenzel, and Gap, Inc.: 21 top right.

Courtesy Lehmann Maupin Gallery, New York: 135 top left.

Courtesy Mathew Marks Gallery, New York: 137 center.

Courtesy Metro Pictures Gallery, New York: 54–61.

Courtesy Craig McDean: 135 top right.

© Joan Munkacsi, print courtesy General Research Division, The New York Public Library, Astor, Lenox and Tilden Foundations: 24 bottom right.

© Joan Munkacsi, courtesy Howard Greenberg Gallery, New York: 14 center left.

The Museum of Modern Art, New York: 17 left; 24 center left; Kate Keller: 30 bottom; Erik Landsberg: 14 top left; Jonathan Muzikar: 14 center left; 17 bottom right; 21 top left; 24 center right; 28; 30 top right; Photography Digital Cataloguing Project: Kimberly Marshall Pancoast, Kai Hecker, Kelly Benjamin: 14 bottom left; 24 top; 30 top left.

© Courtesy Pace/MacGill Gallery, New York: 131.

Courtesy Mario Sorrenti: 135 bottom right.

Courtesy Deborah Turbeville and Staley–Wise Gallery: 28 bottom.

© 1985 Village Voice Media, Inc. Reprinted by permission of *The Village Voice*: 21 bottom right.

© Bruce Weber, courtesy Little Bear: 137 top.